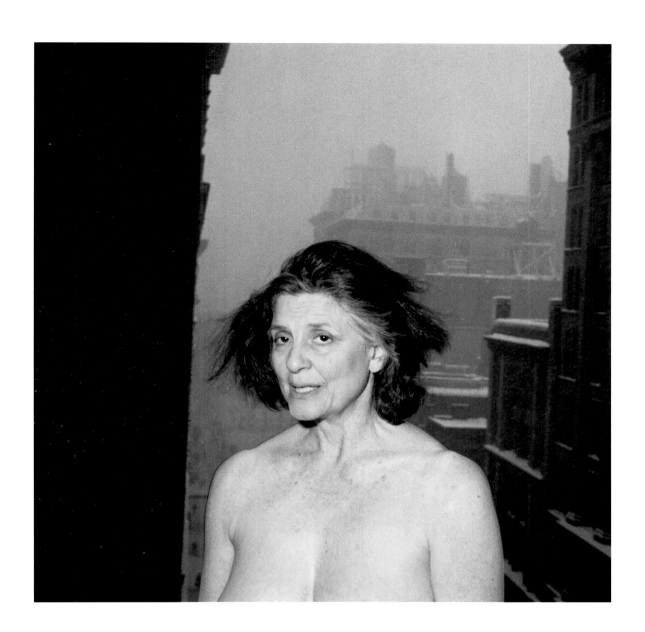

Got to Go

Rosalind Fox Solomon

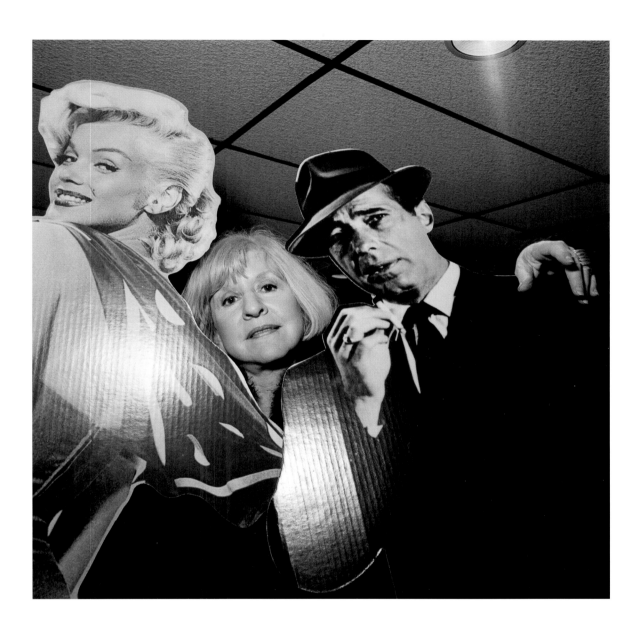

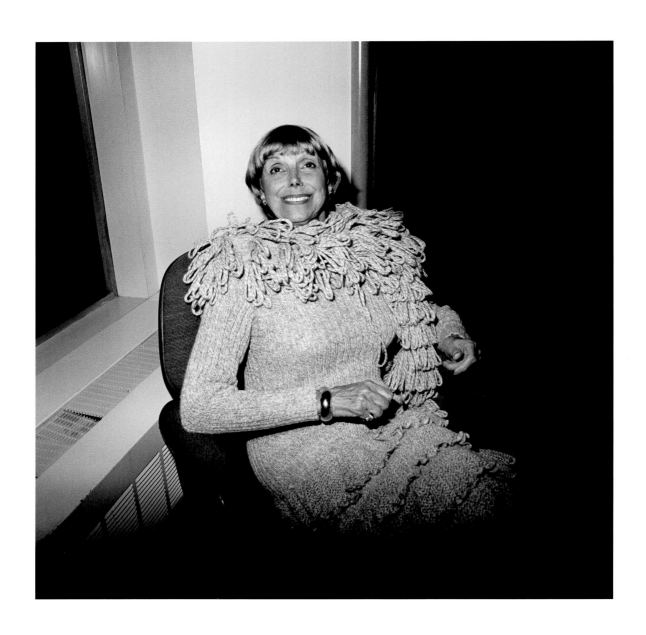

mother says youth is my god
i hate age
everything is such an effort
i take benzedrine
to cope with my aches and pains
last time before they operated on me
i ate thirty hershey bars
then i found out that i have diabetes
no hersheys tonight boo hoo
nothing can help me now but a new leg
hip hip hurray
i'm getting intravenous tonight
i don't know whether it's the appetizer
or the post-mortem
yesterday i thought i would congeal
my feet are just like ice
in a few days i'll be a dead ass
there will be no tomorrow

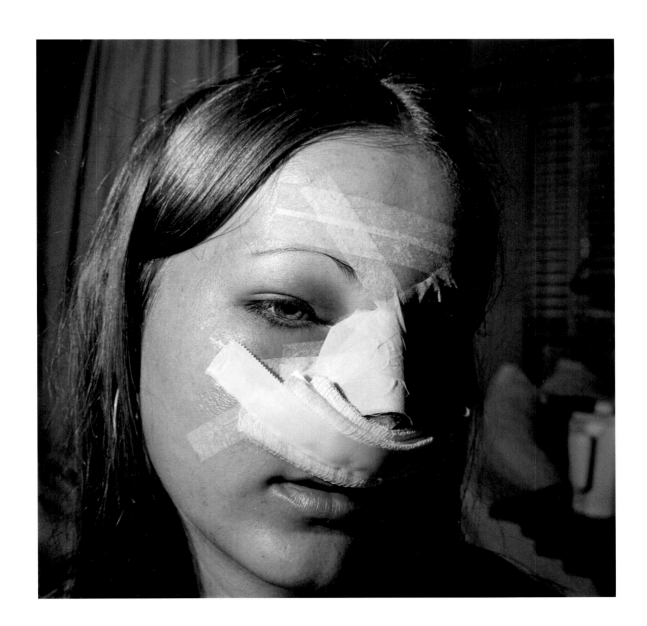

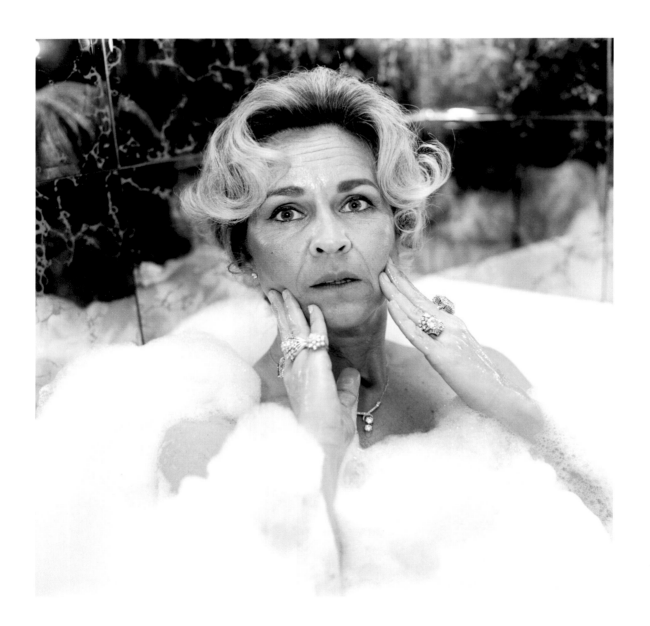

i never knew which i hated most:
my breasts, my nose or my name

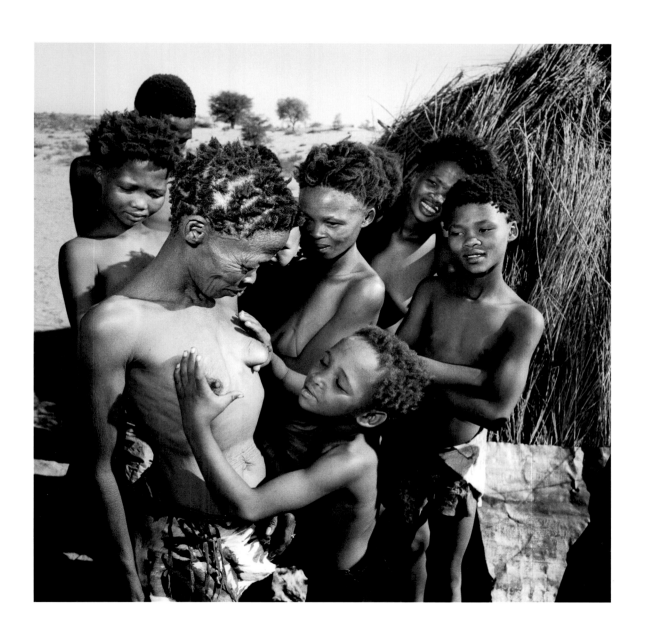

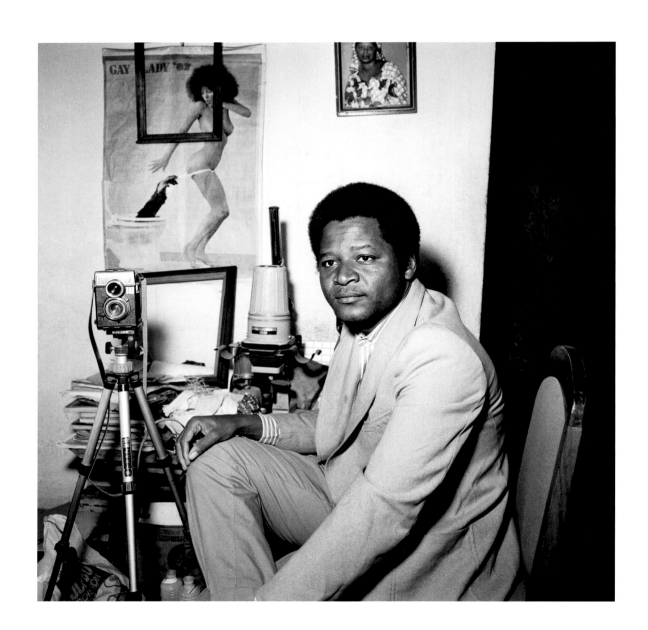

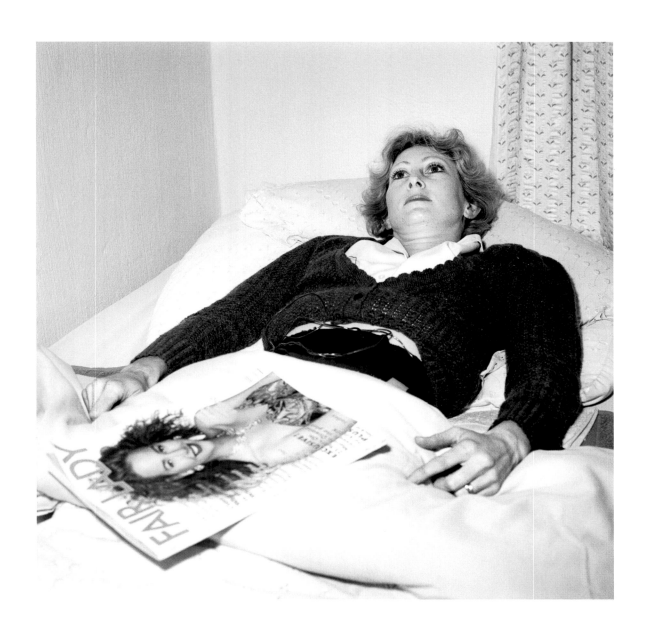

mother says, i like male attentions of all kinds
because i'm female through and through

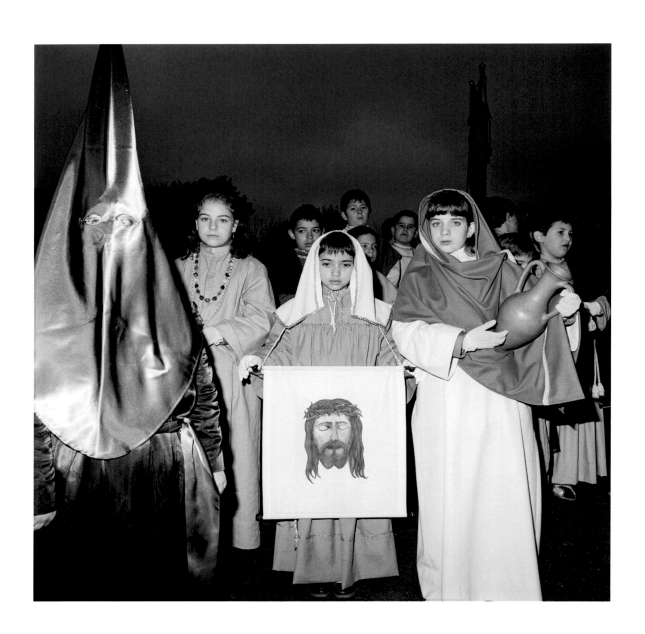

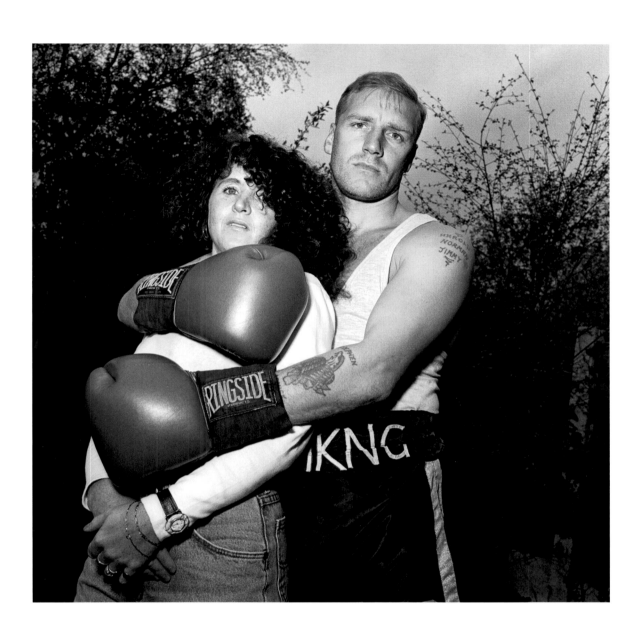

i love being taken care of

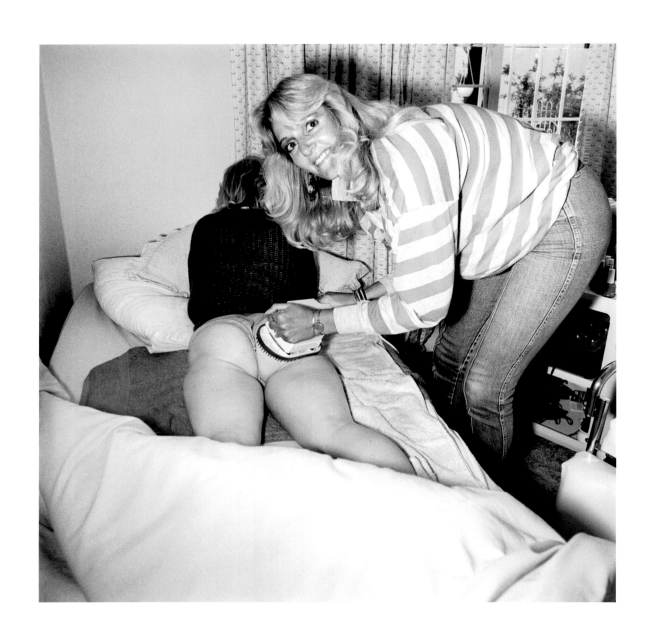

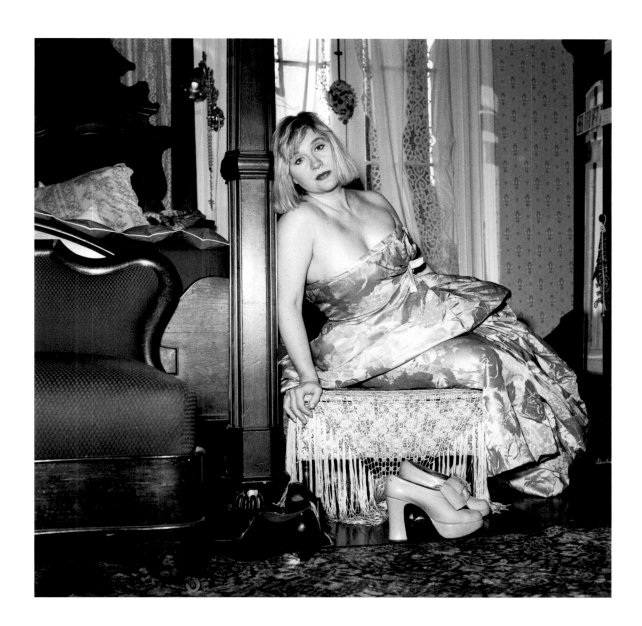

i am
the acme of a lady
women's lib
will make life
miserable
i like chivalry
i like
a man's arm
helping me
up and down a curb
i'm not independent
why should i be?
i'm spoiled rotten

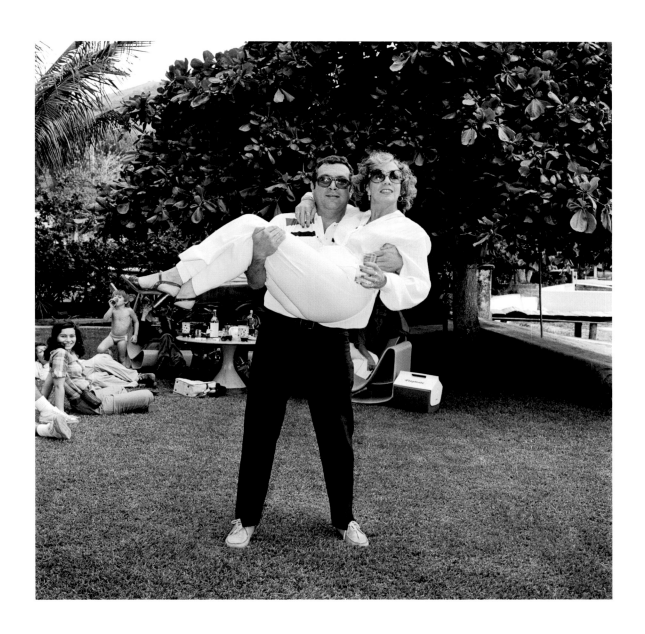

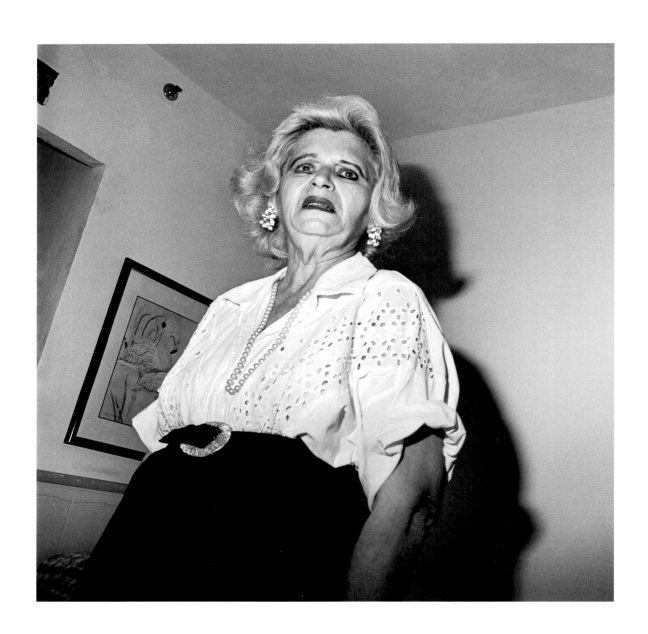

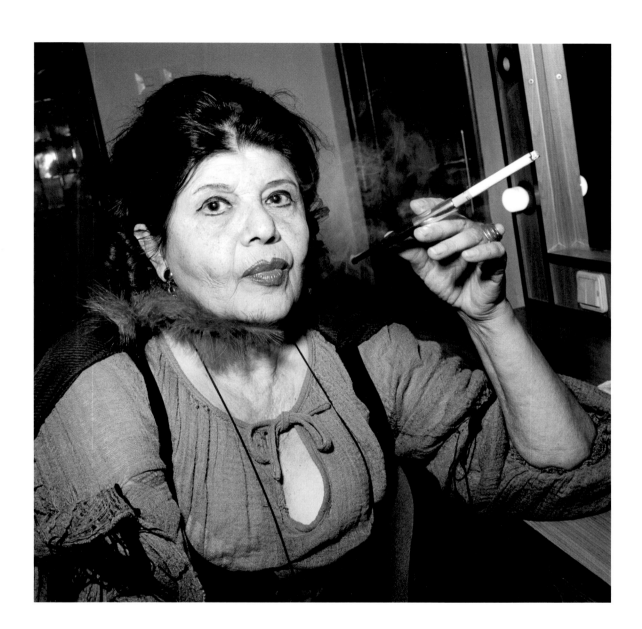

mother says

KEEP YOUR ELBOWS OFF THE TABLE
STOP STRETCHING YOUR NECK
STOP BLINKING
DON'T GULP YOUR FOOD
EAT LIKE A LADY

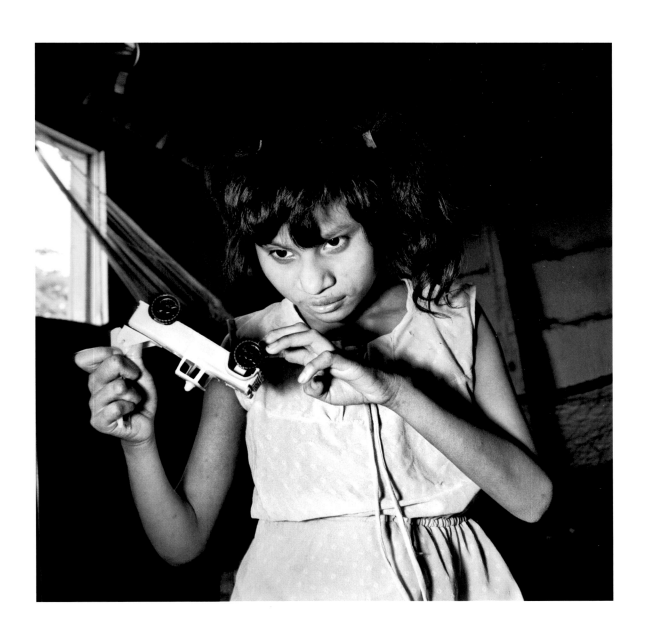

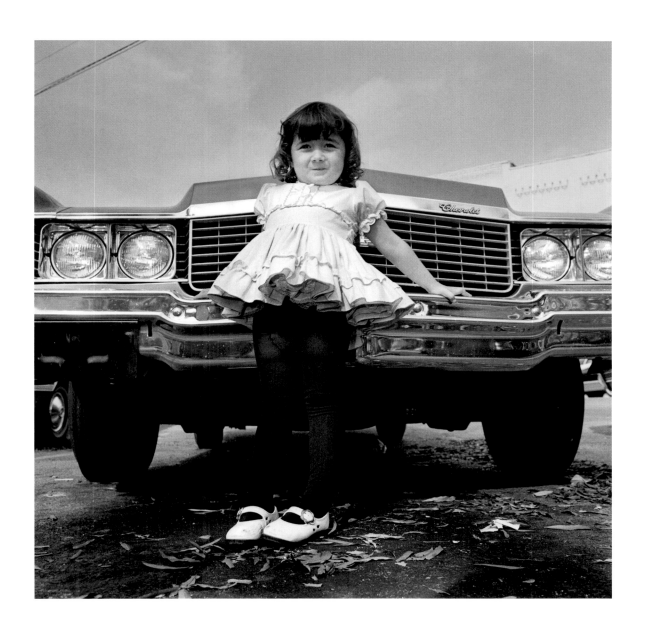

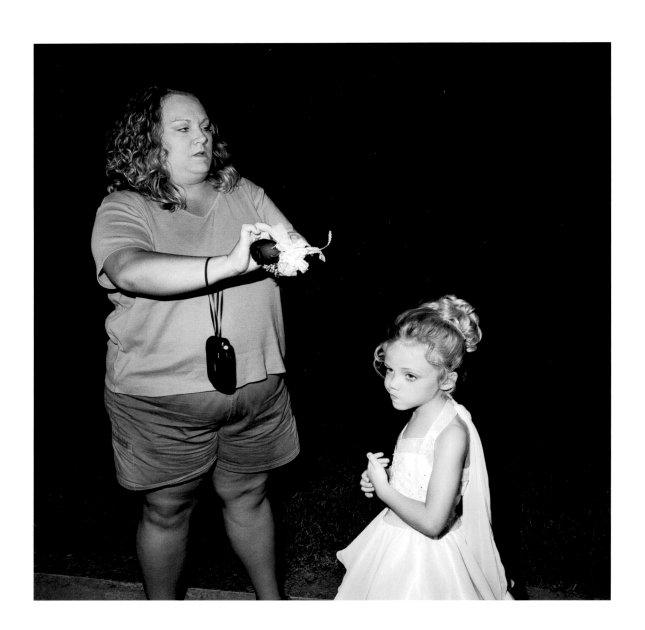

you are
a naughty
 naughty
 girl

mother says

GO
LIVE WITH THE MILKMAN'S DAUGHTERS
EAT TOASTED CHEESE FOR DINNER
TAKE YOUR SUITCASE
DON'T COME BACK

she locks the door
i stand
outside
alone

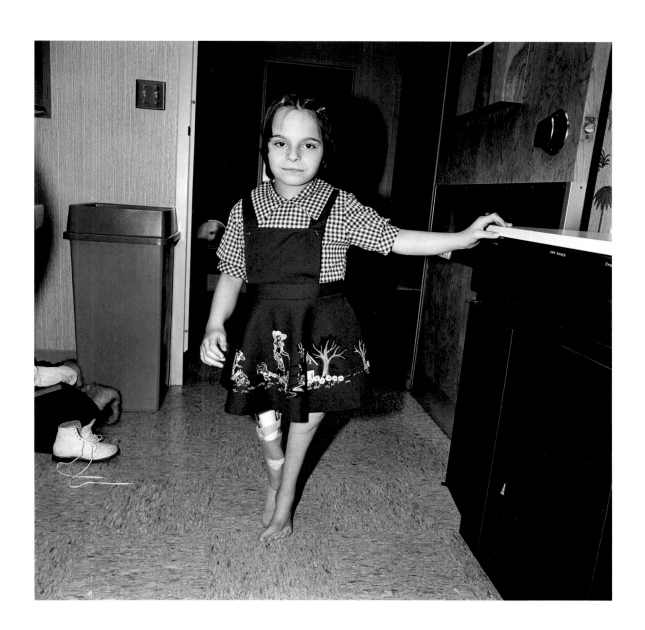

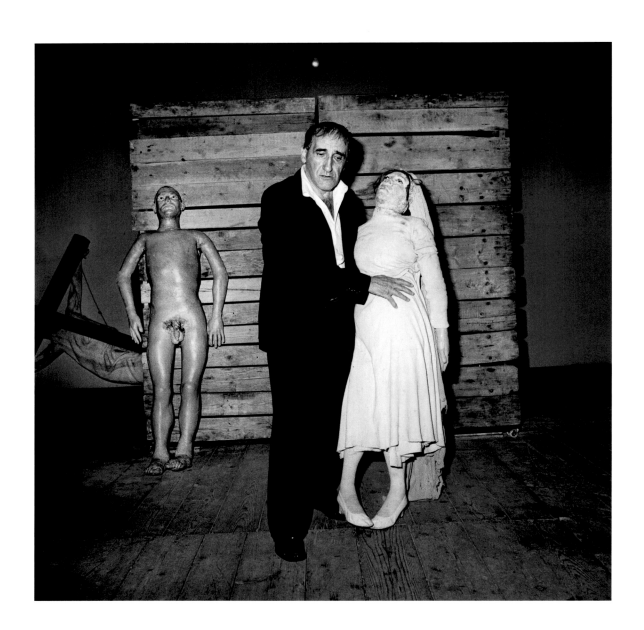

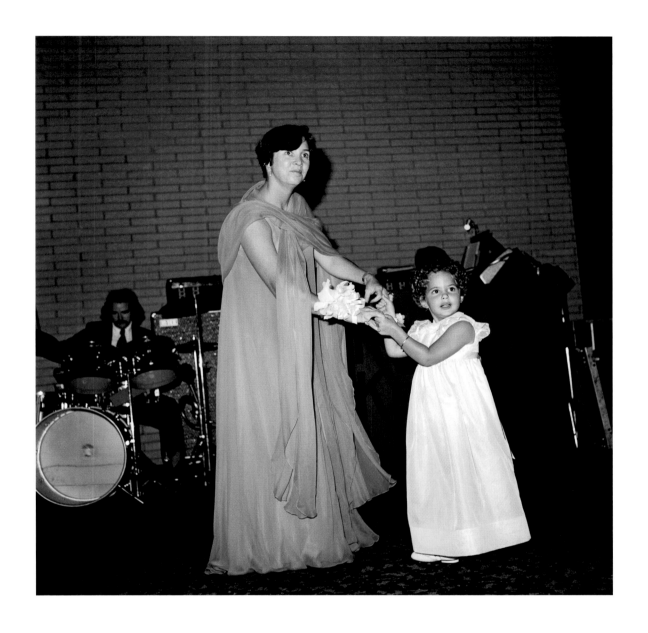

mother says

YOUR FATHER CHANGED YOUR DIAPERS
UNLOCK THE BATHROOM DOOR
LET HIM IN

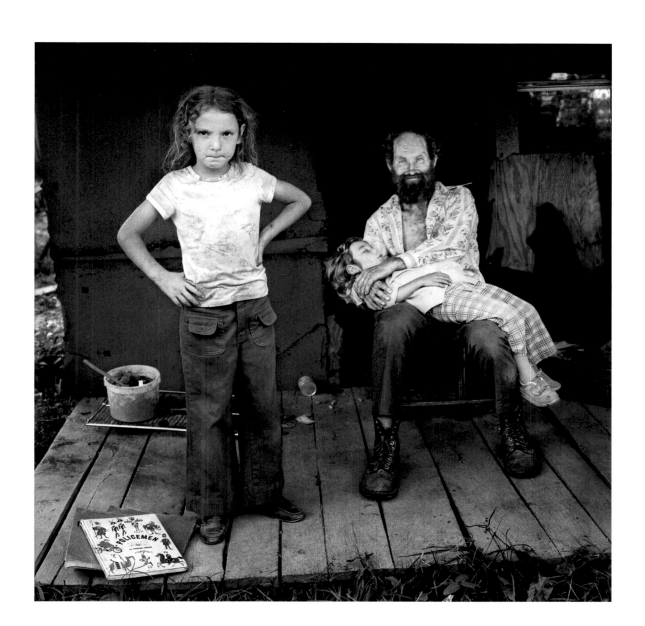

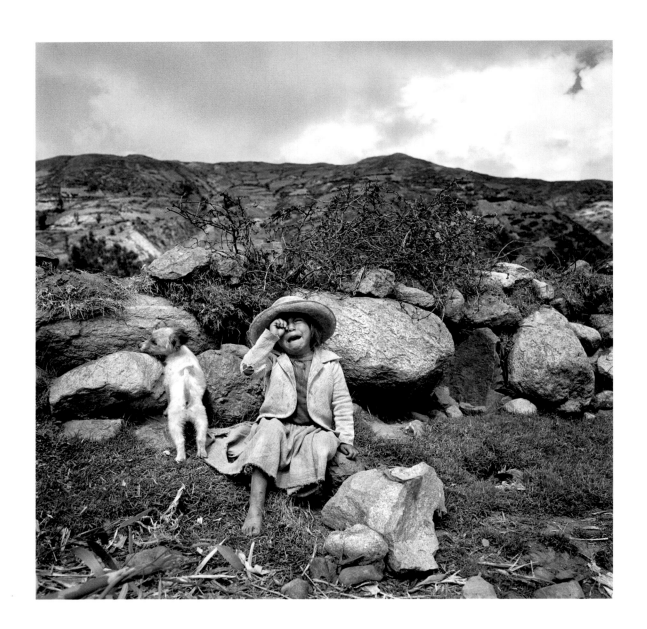

i peed in the woods
at dinner i say
 excuse me

 i've got to go...

 got to go wee wee

mother says
i saw you!
got to go?

GO OUTSIDE
IF YOU ACT LIKE A DOG
LIVE LIKE A DOG

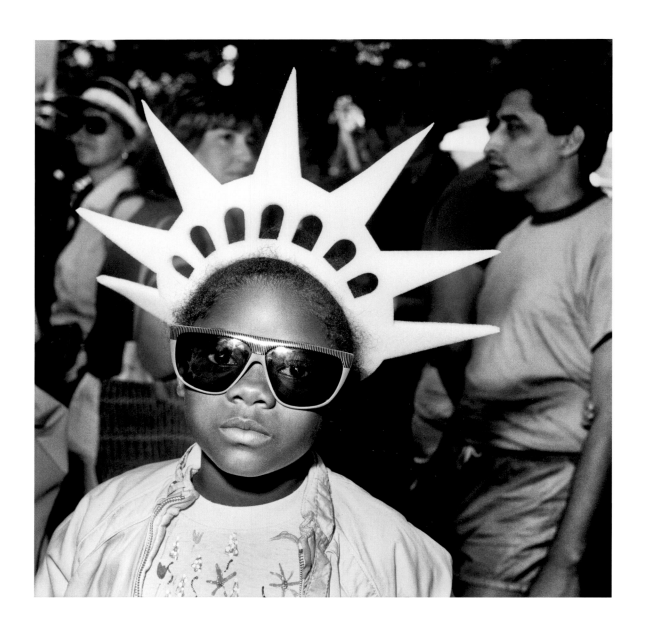

mother says

SMILE, YOUR FACE WON'T CRACK

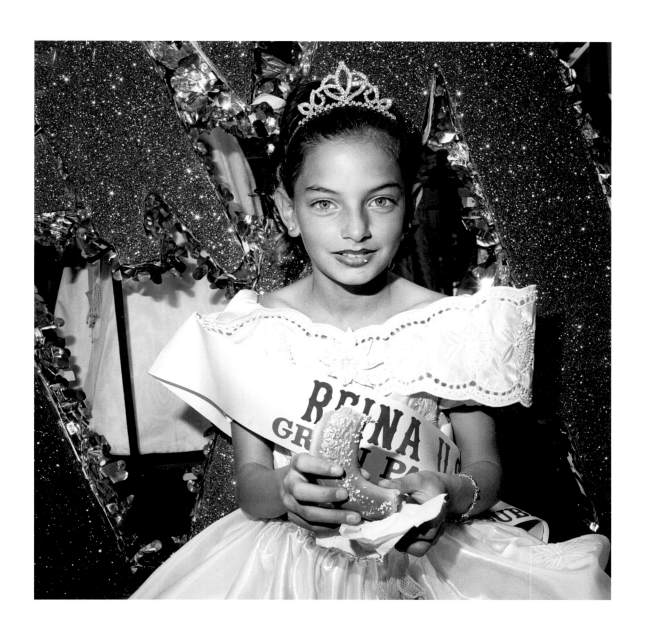

mother says

WIPE THAT SMILE OFF YOUR FACE

mother says

PUT A SMILE ON YOUR FACE
GO BACK TOMORROW
YOU'LL BE FINE

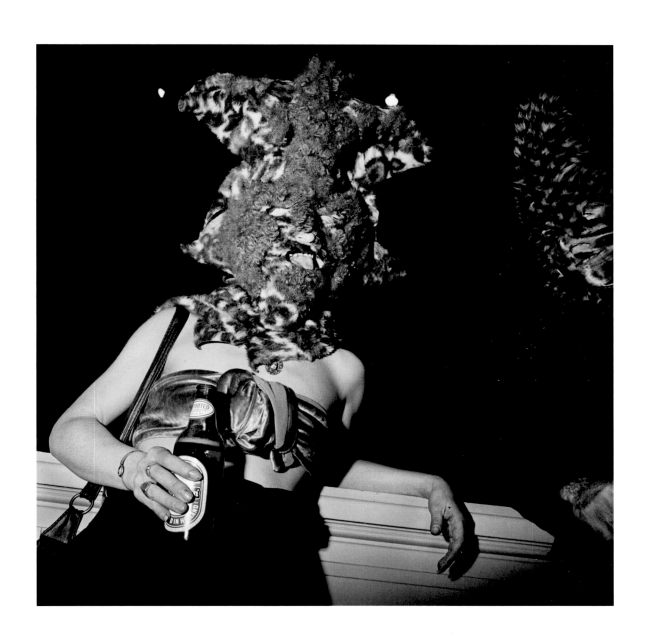

i say

they pulled my hair
it's falling out

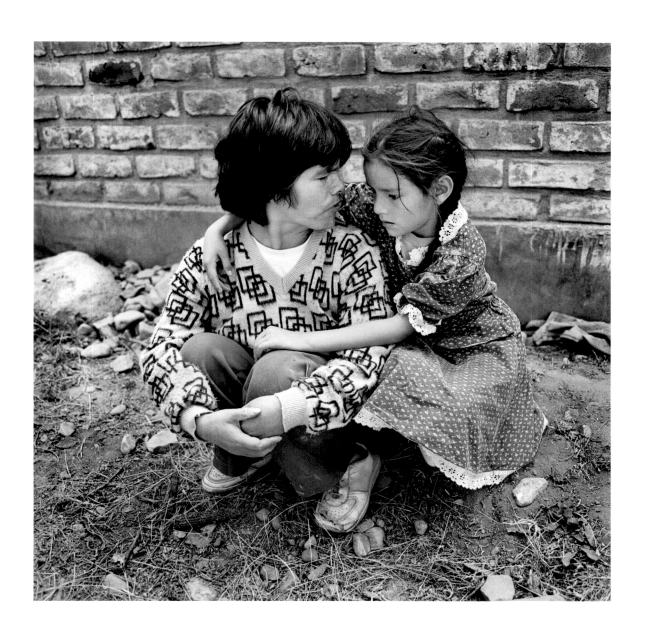

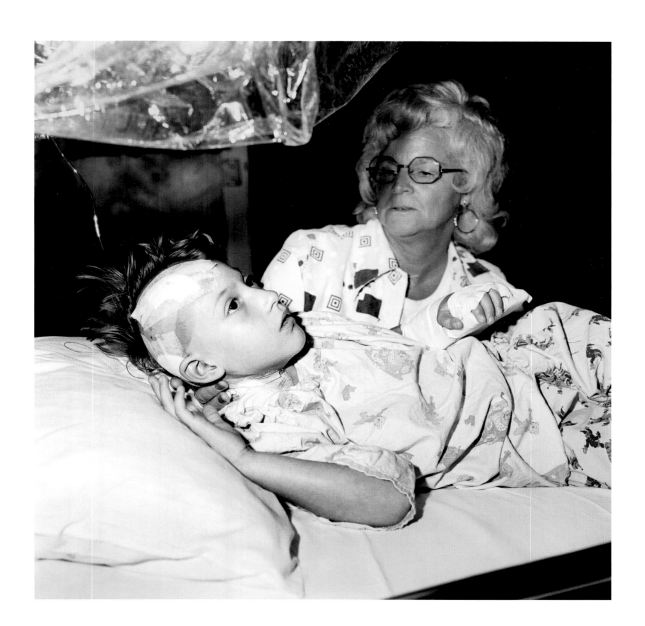

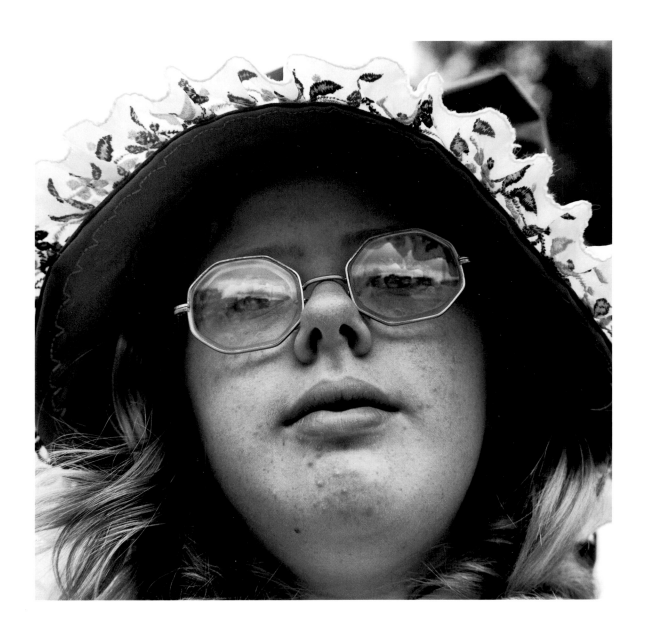

they call me piggy

i eat
brown sugar and whipped cream
nothing fills my emptiness

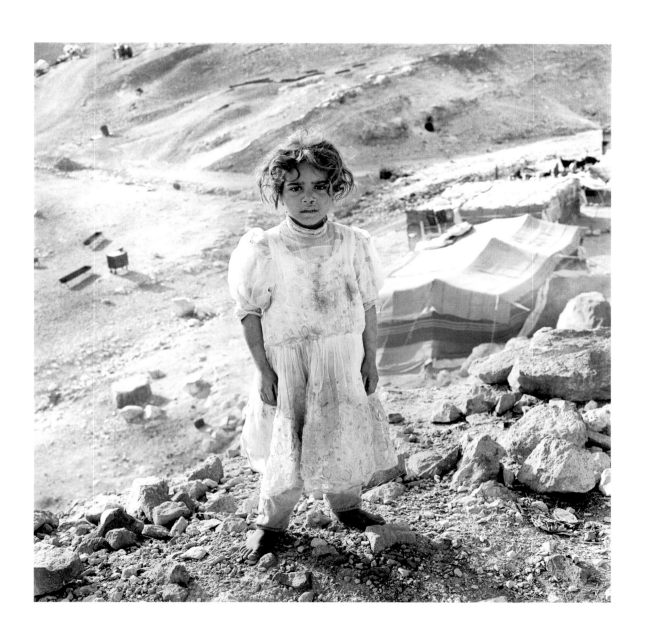

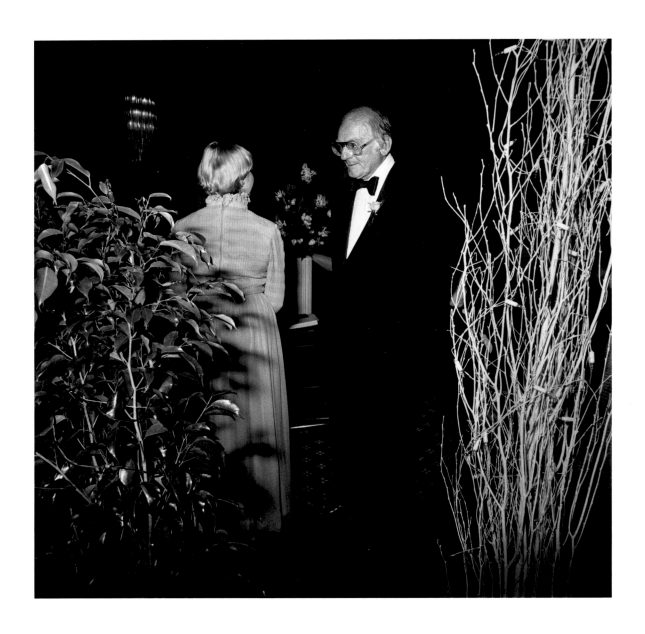

keys keys keys
you can't get your affection without the right key

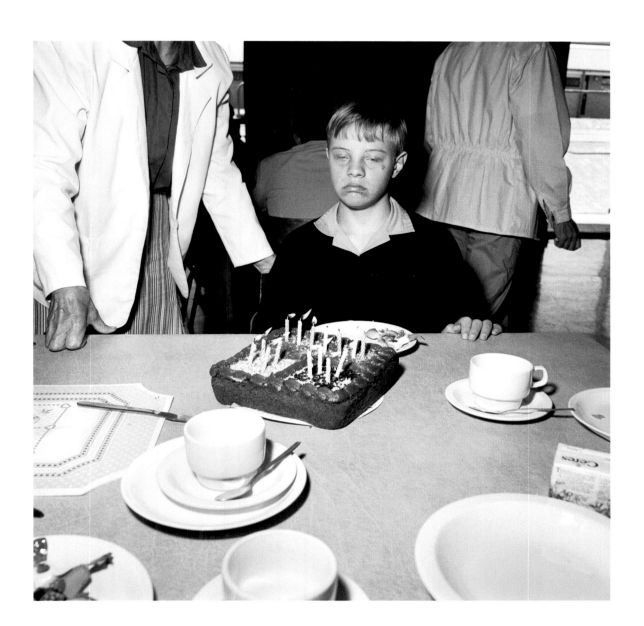

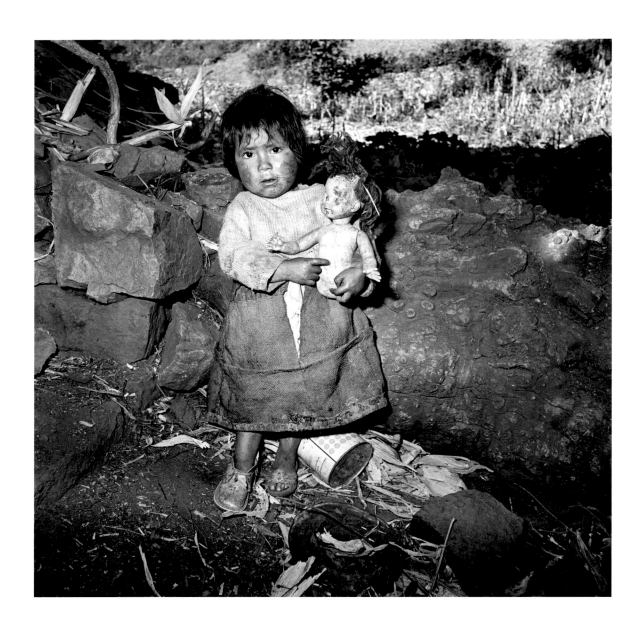

father sings to me

sweetest little baby da da da da da
he blows in my ears. kisses my fanny
dandles me on his knees
don't know what to tell you but she's mighty like a rose

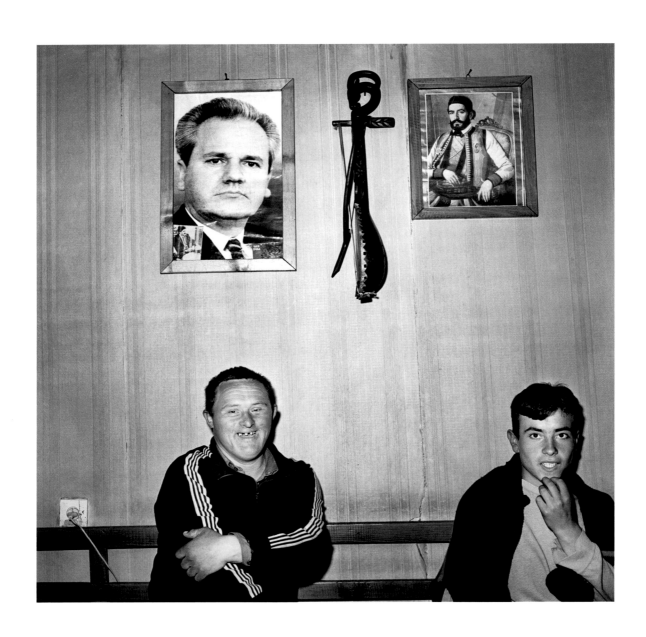

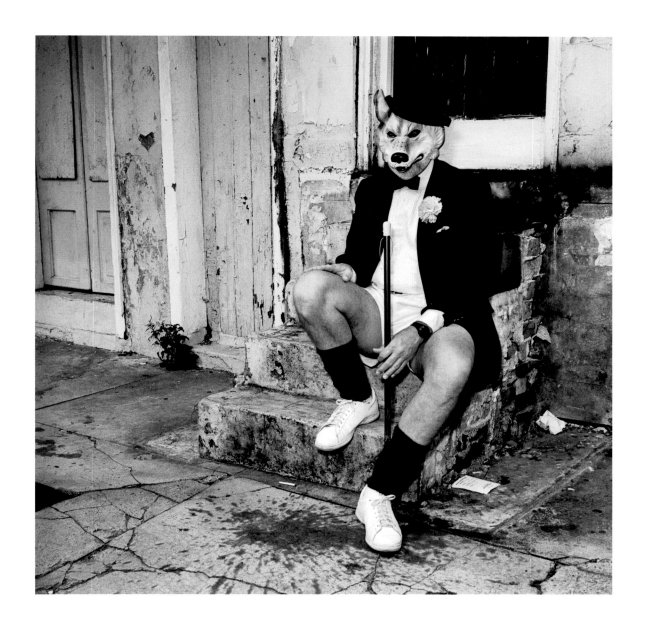

father lays me over his knees
and spanks me hard as he can

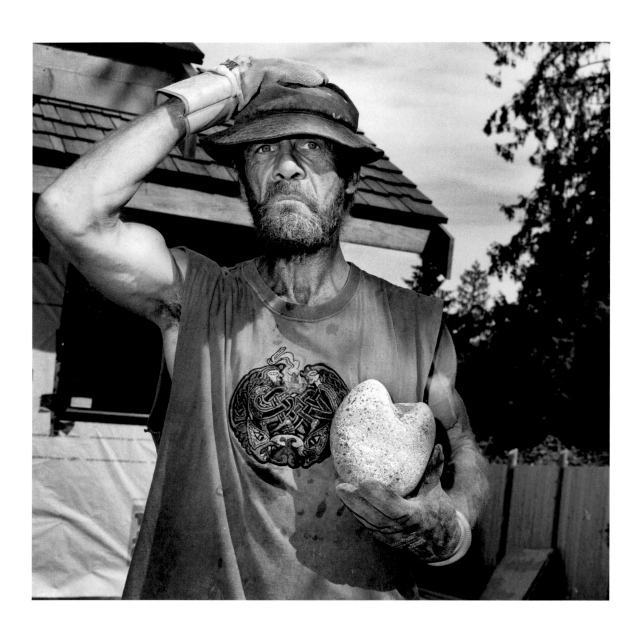

HAND ME YOUR MOTHER'S HAIRBRUSH
TAKE DOWN YOUR PANTS
NOW READ NUMBER ONE...

i slammed a door

GET DOWN OVER MY KNEES

smack

PICK UP THE BLACK CRAYON AND
CROSS OFF NUMBER ONE
READ NUMBER TWO

ayyyy i raised my voice and talked too loud
i ran...i ran...up and down...the stairs

BACK OVER MY KNEES

smack

oh you beautiful doll, you great big beautiful doll

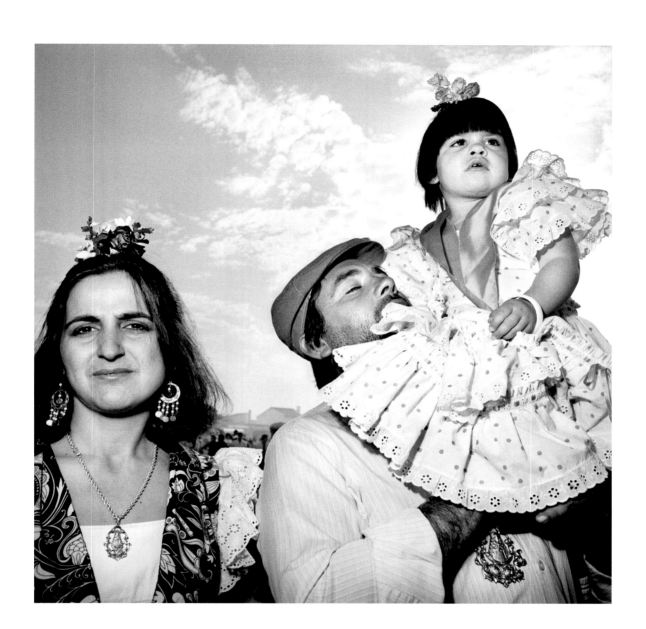

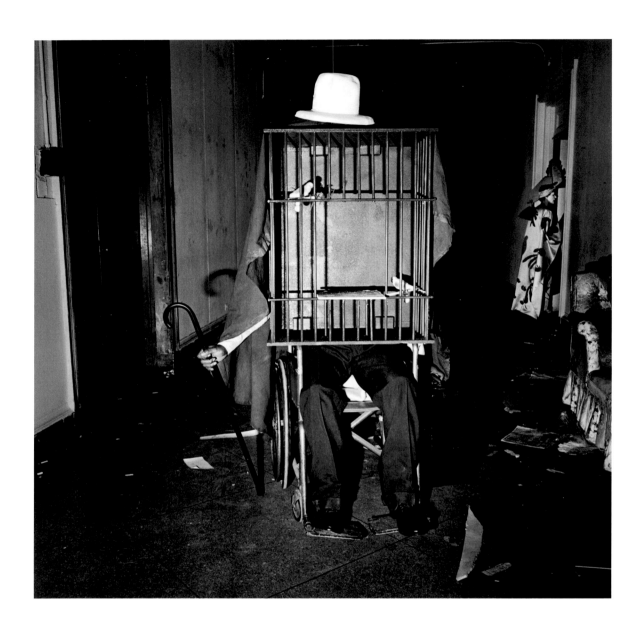

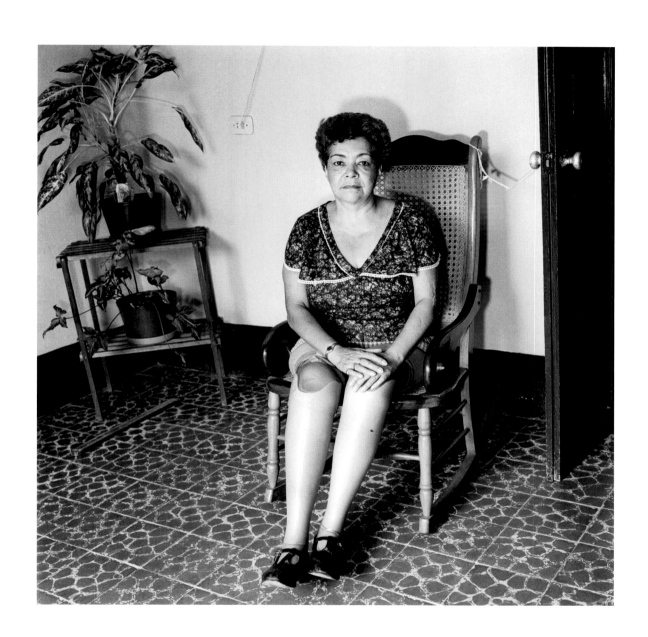

mother says to father

I'D LIKE TO STICK A RED HOT POKER UP YOUR REAR END

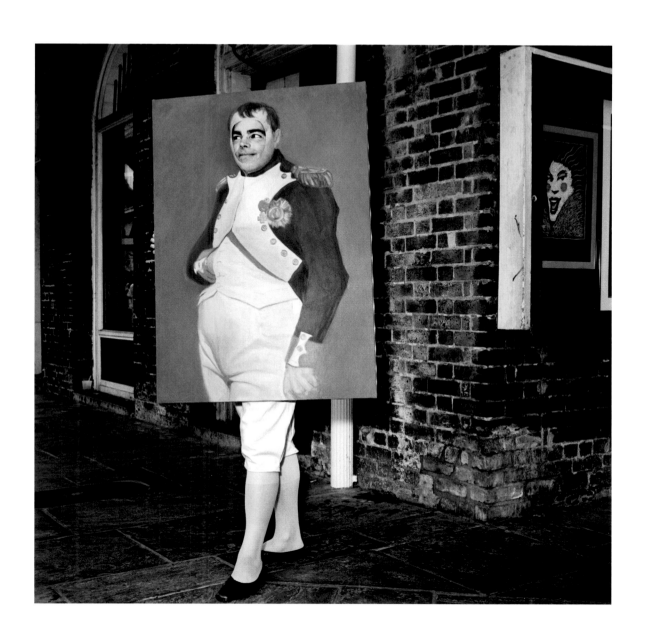

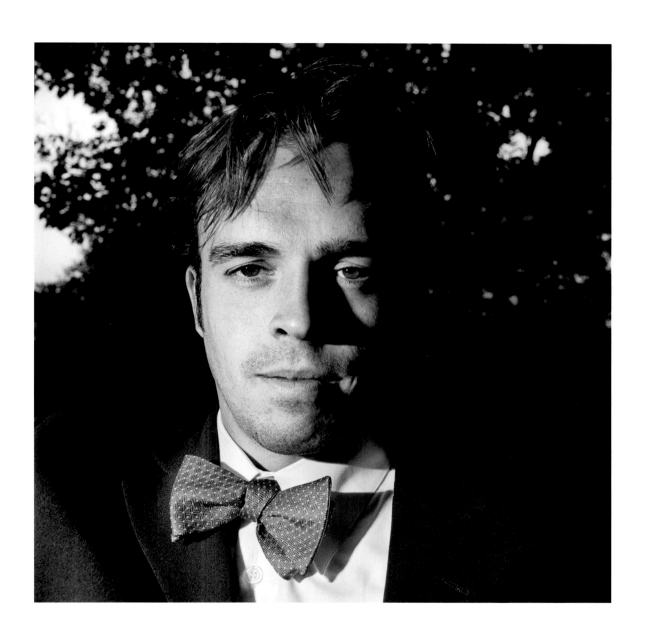

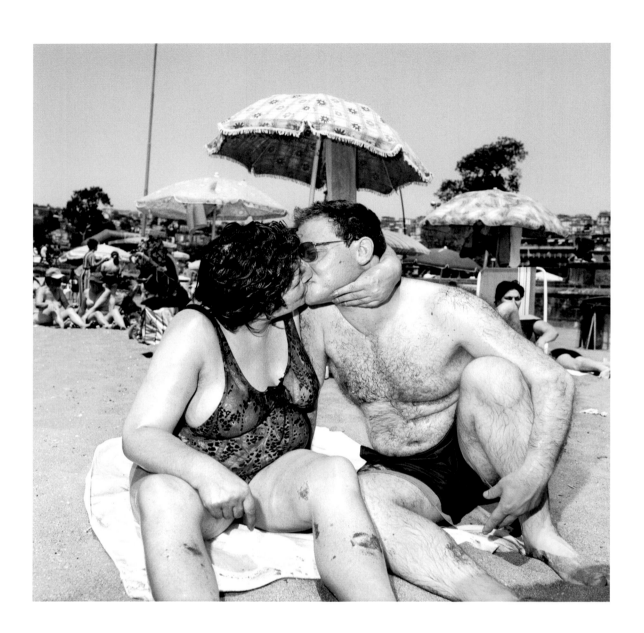

someone let the cat out of the bag

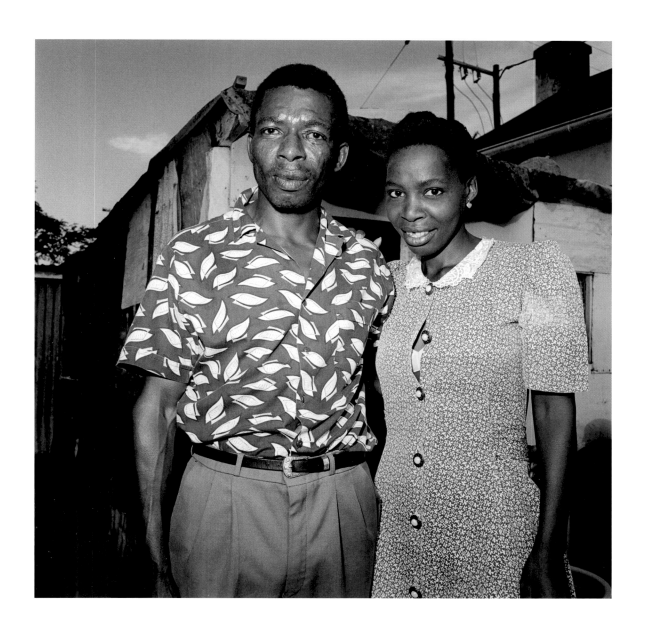

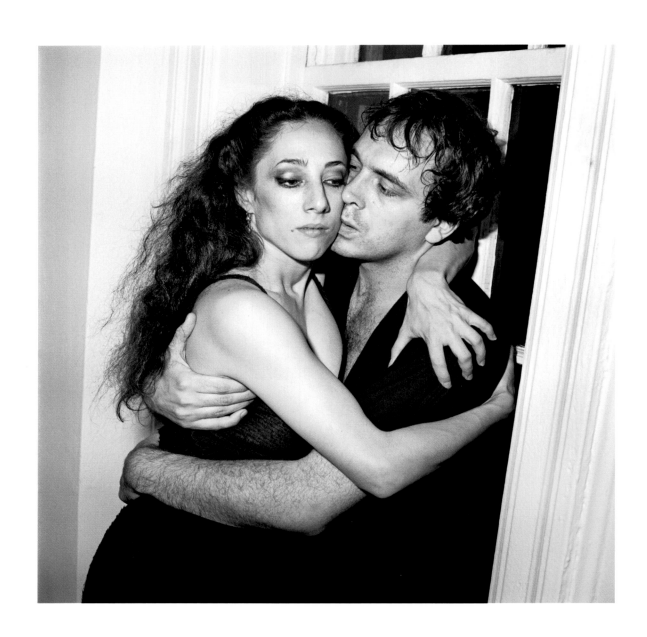

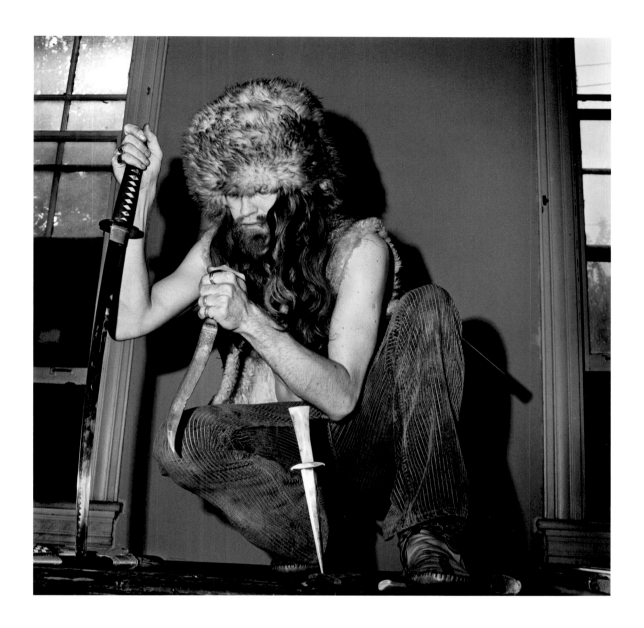

father is having an affair

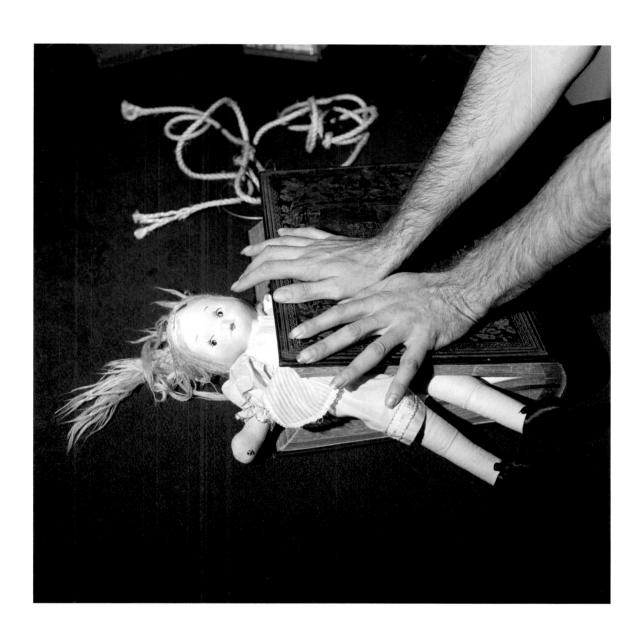

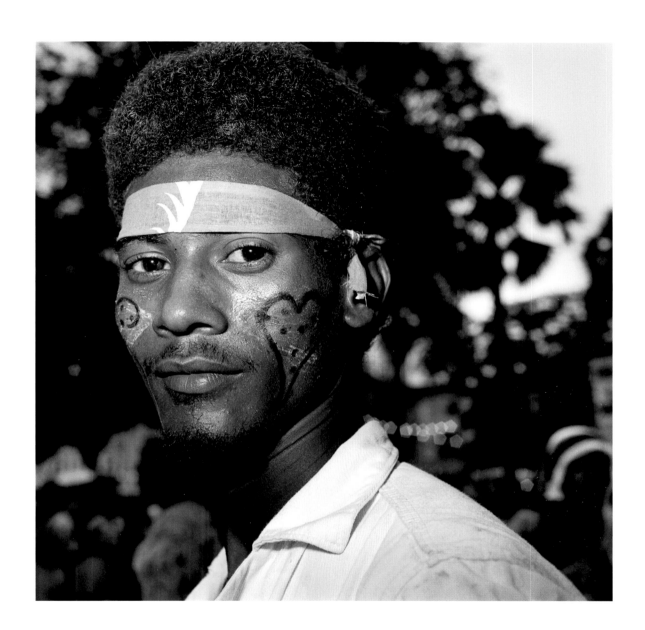

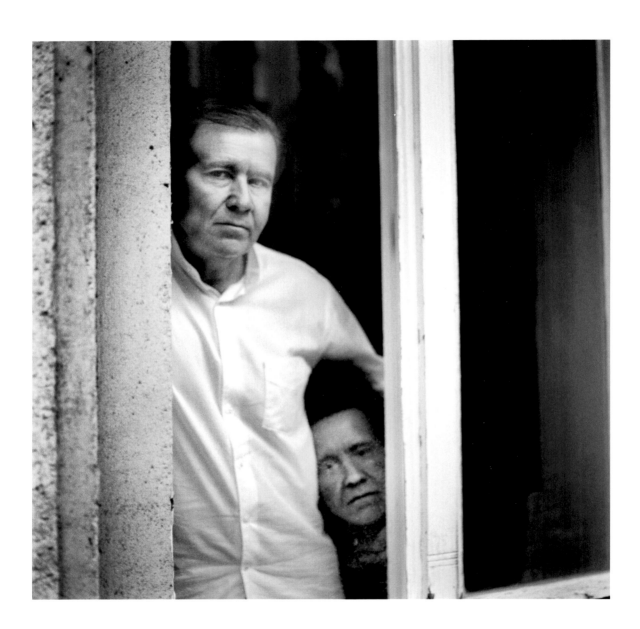

mother says

i was away
you left your father alone
IT'S ALL YOUR FAULT

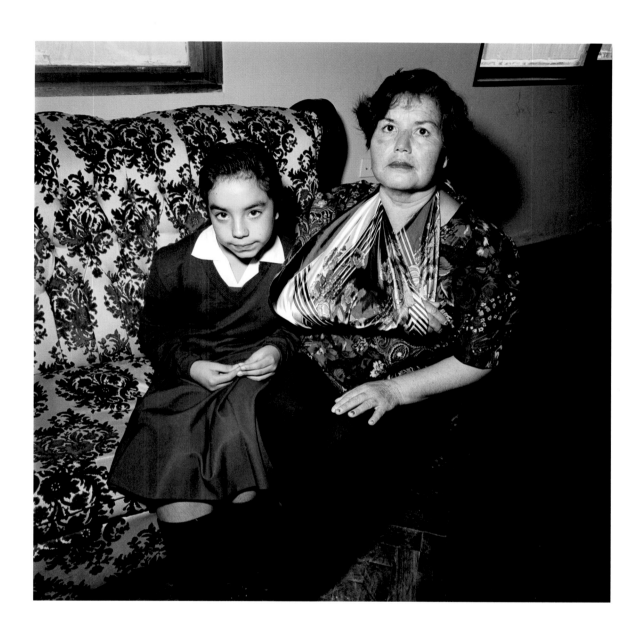

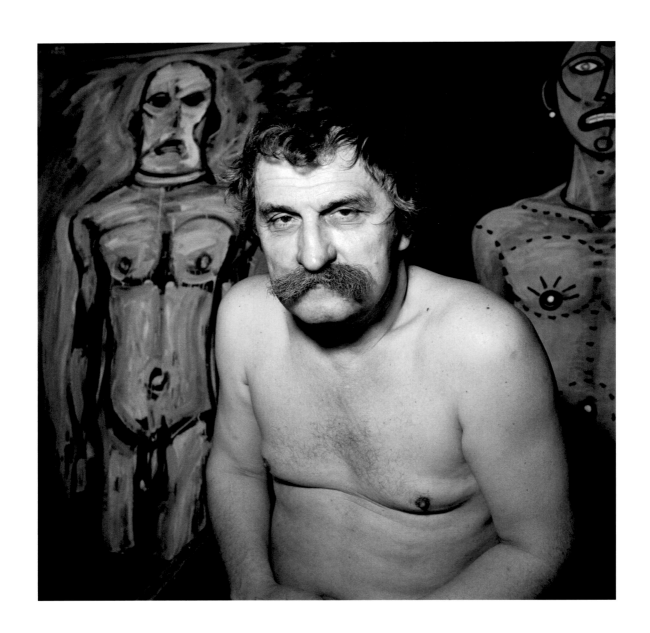

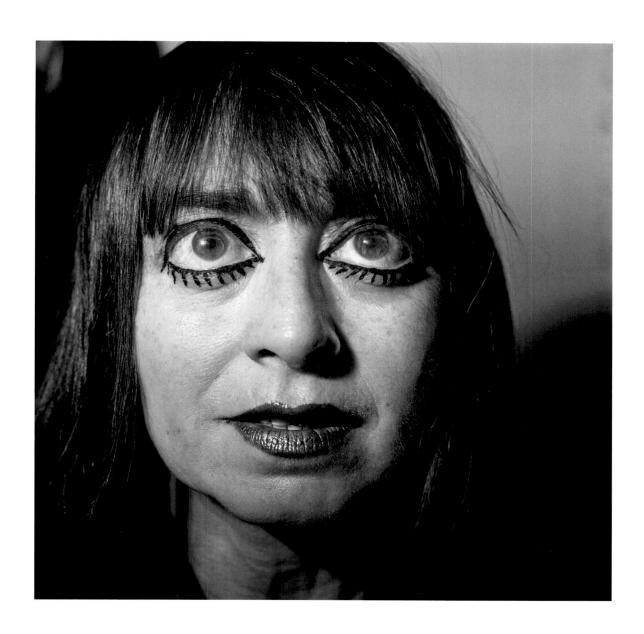

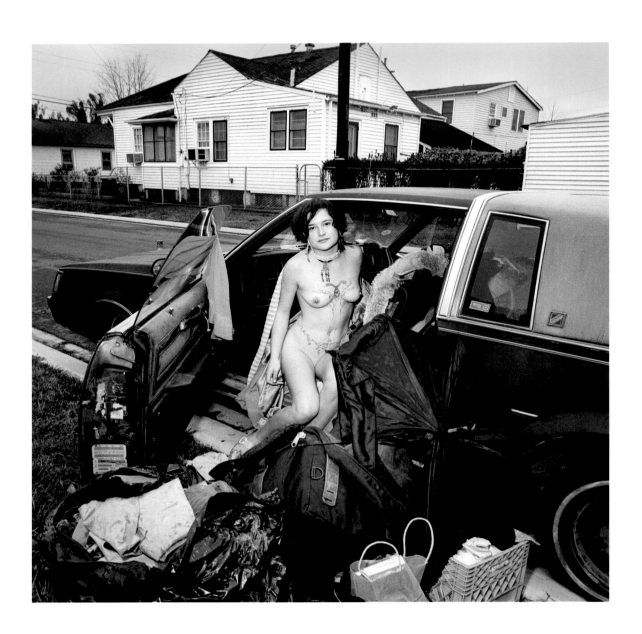

Mother closed the garage door. She turned on the car ignition. She became groggy, imagining herself on a path that began high above the beach.

The moon shone bright and she easily found her way down one hundred steps to reach the sand. She stood sobbing, her white nightgown blowing in the wind. She wondered how she could. Water lapped against her ankles. She began to walk on the sandbar. Her body followed her feet until they rose and kicked. She floated on her back. Waves took her far away from the shore. Then she knew that she could still live with him, but it was too late. When the tide came in they would find her.

A voice echoed through the water. The gardener opened the car door. She muttered about the waves and gasped for air as he helped her into the house.

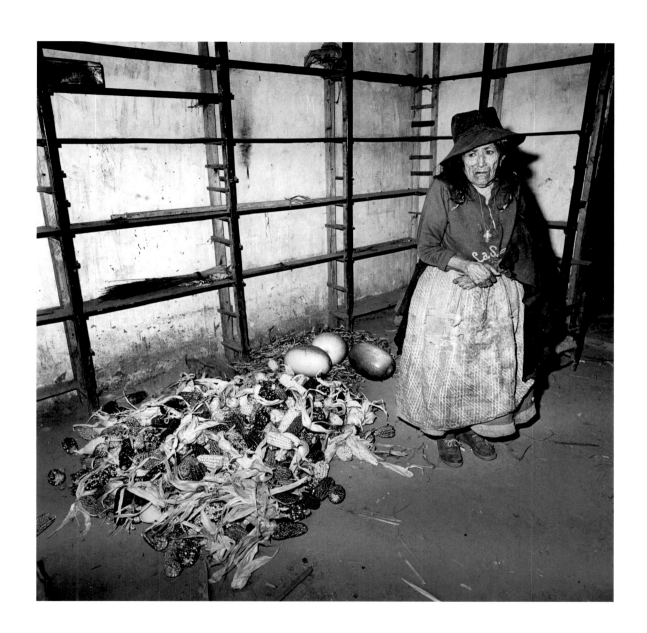

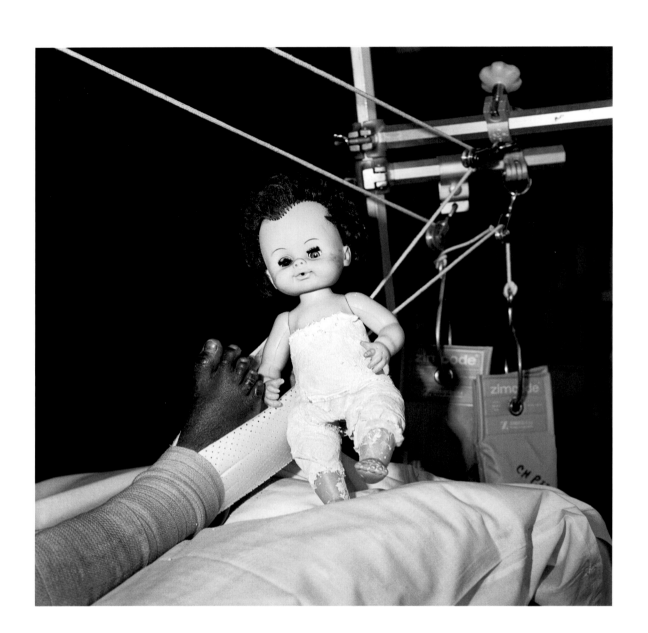

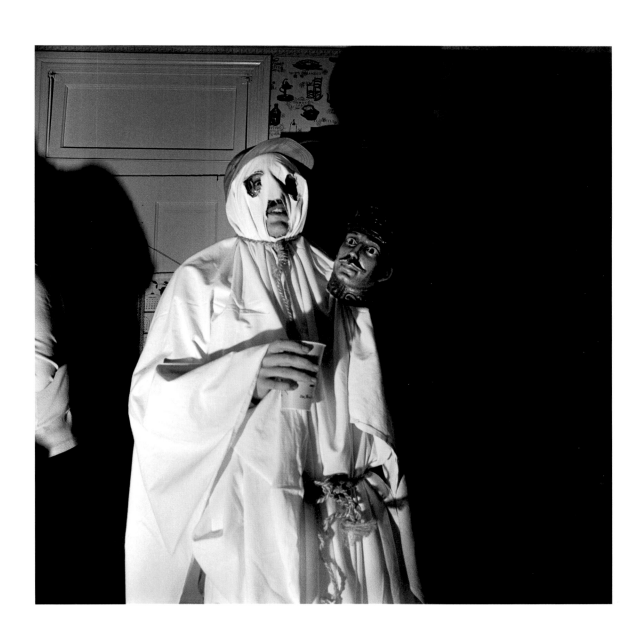

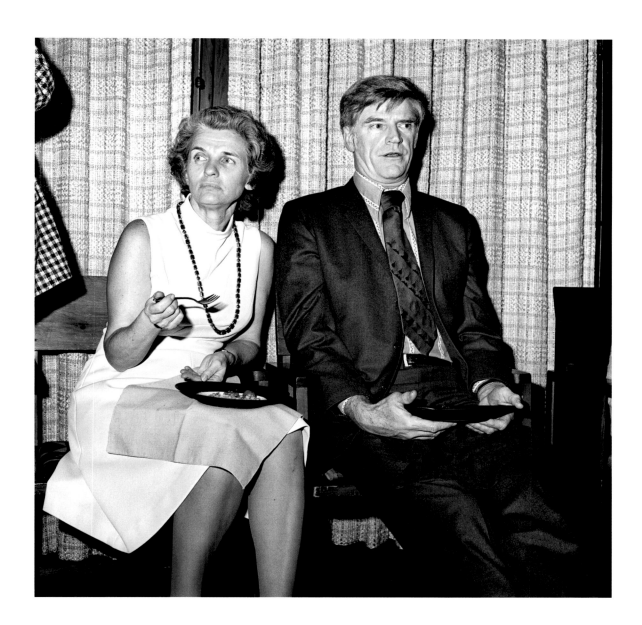

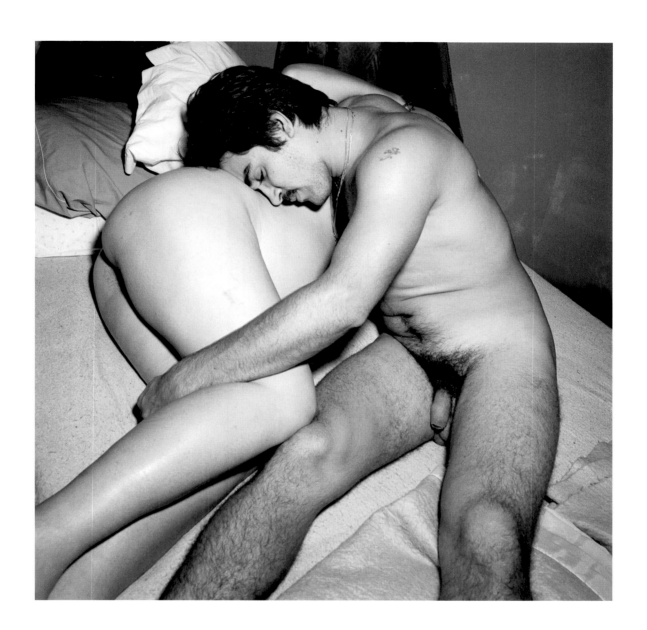

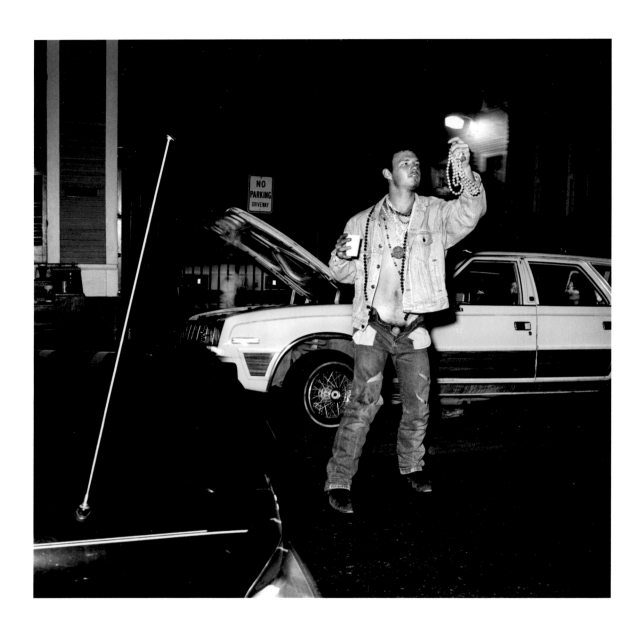

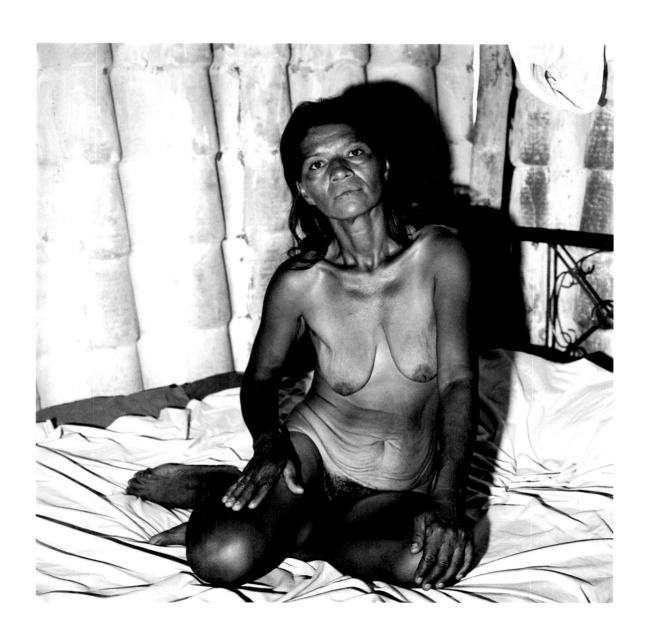

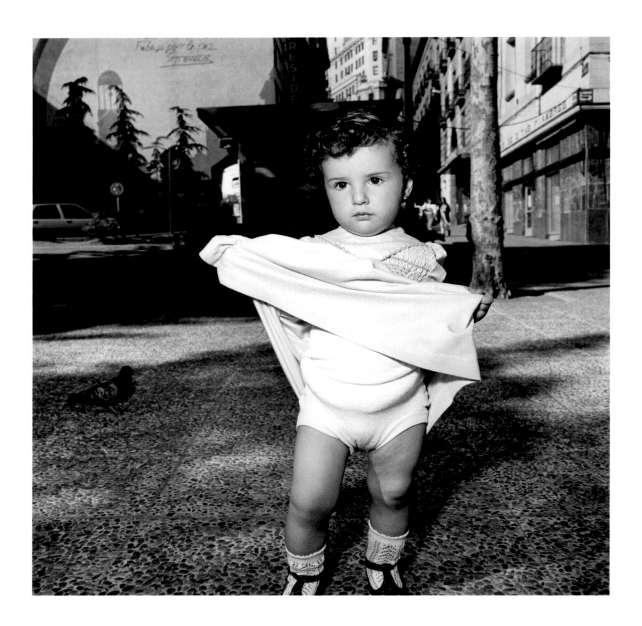

mommy and daddy naked makes me feel funny

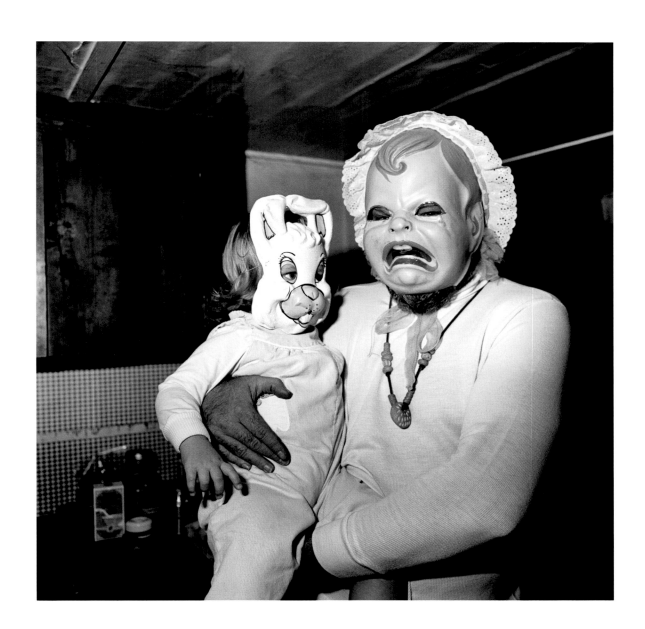

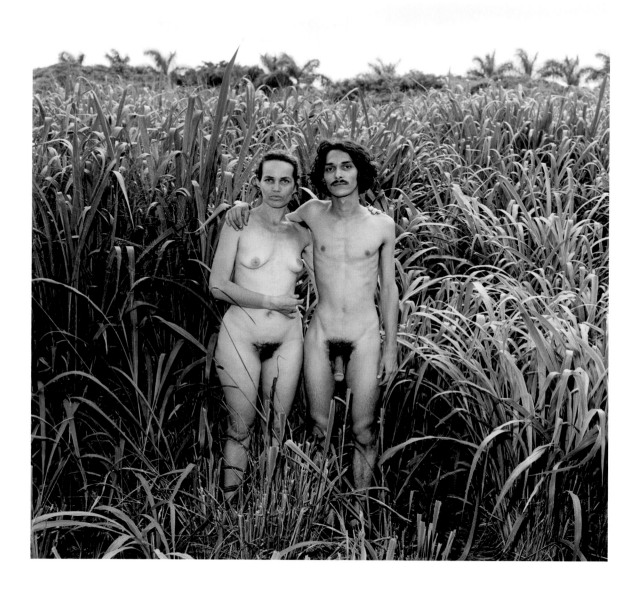

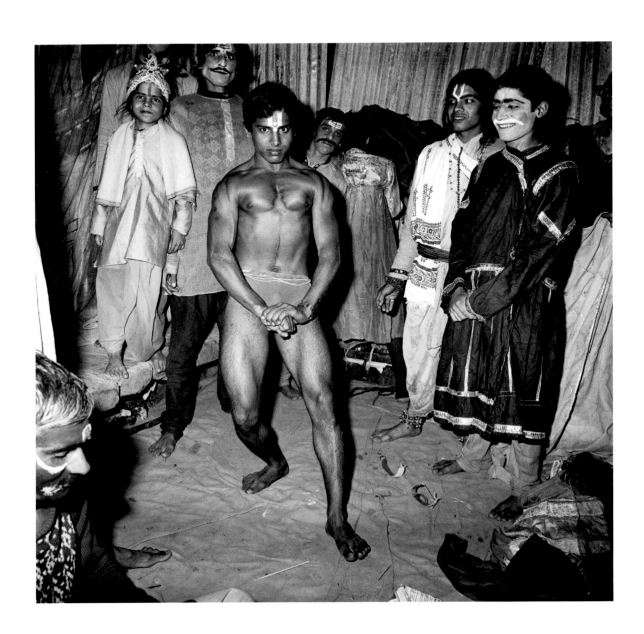

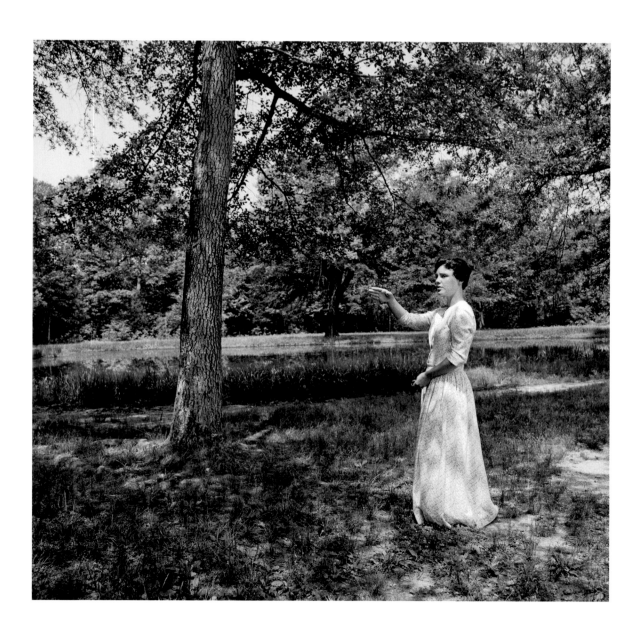

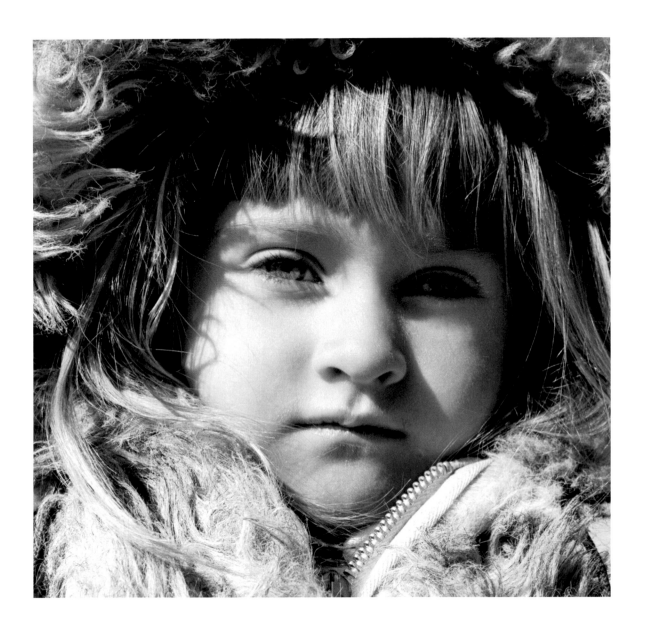

father says

why buy a cow if you can get the milk for free?

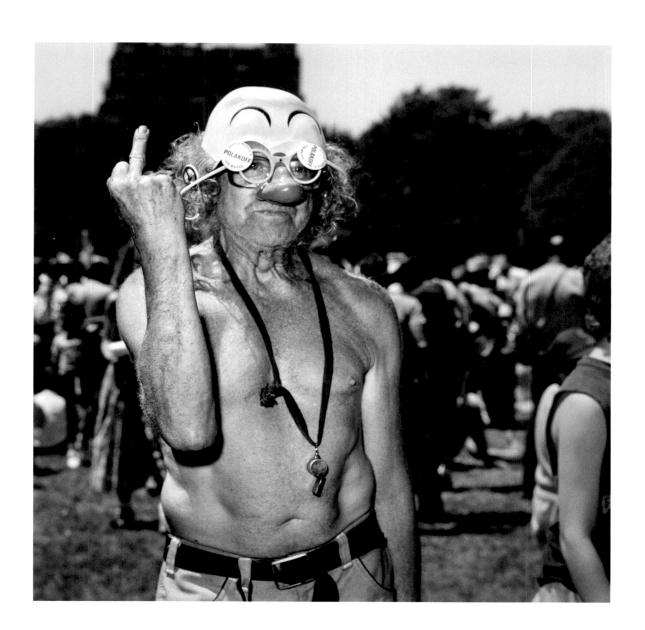

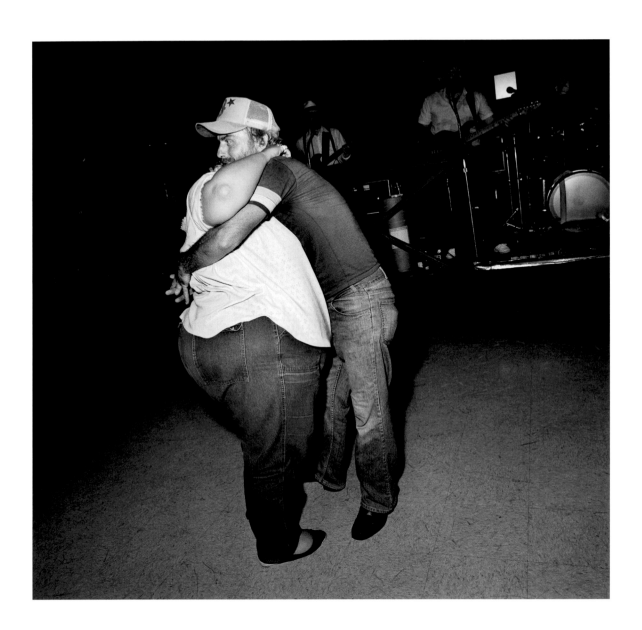

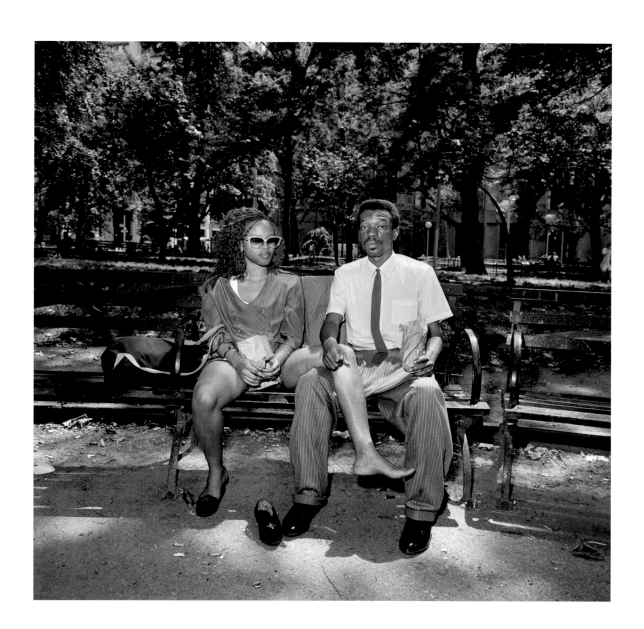

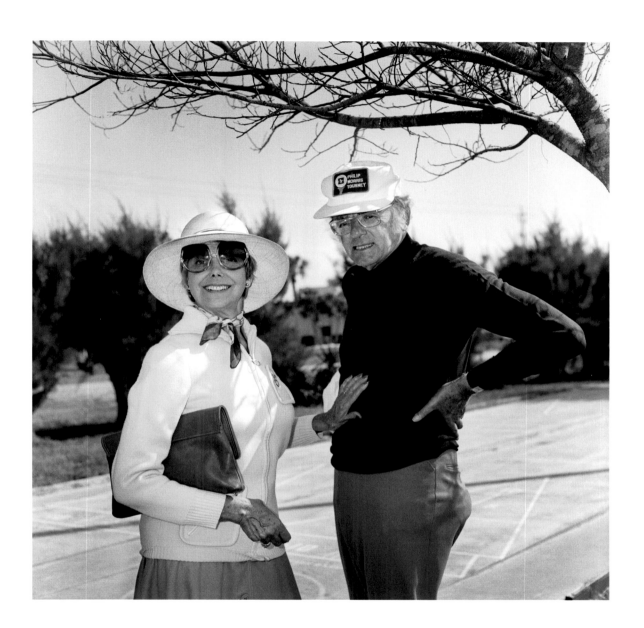

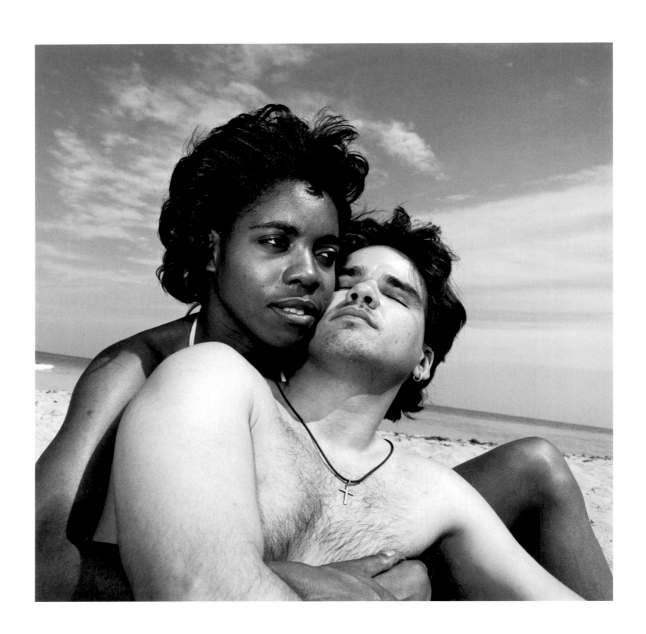

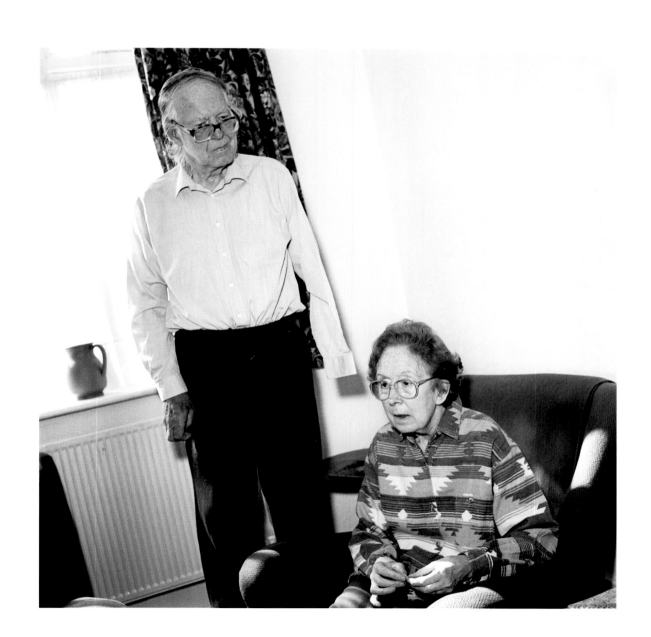

she pushes her walker
wonders
about the fall of the roman empire
eyes pair of high heels passing
thinks
money troubles
too much fighting
ambulance horns...hang on tight
don't want to fall

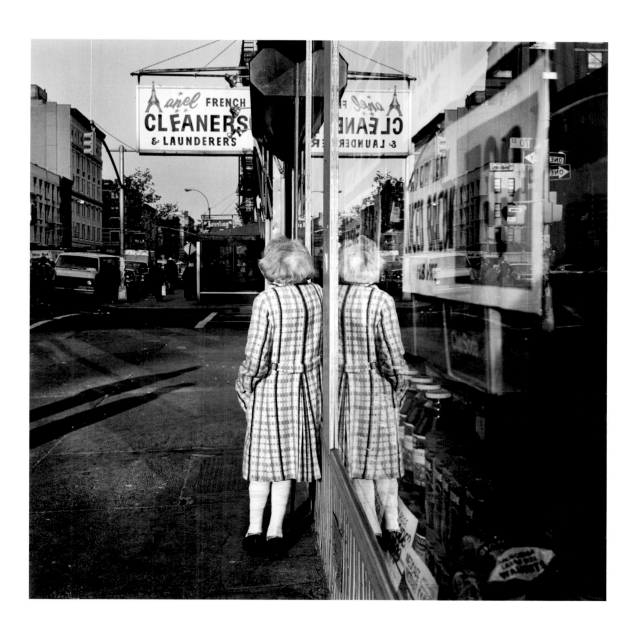

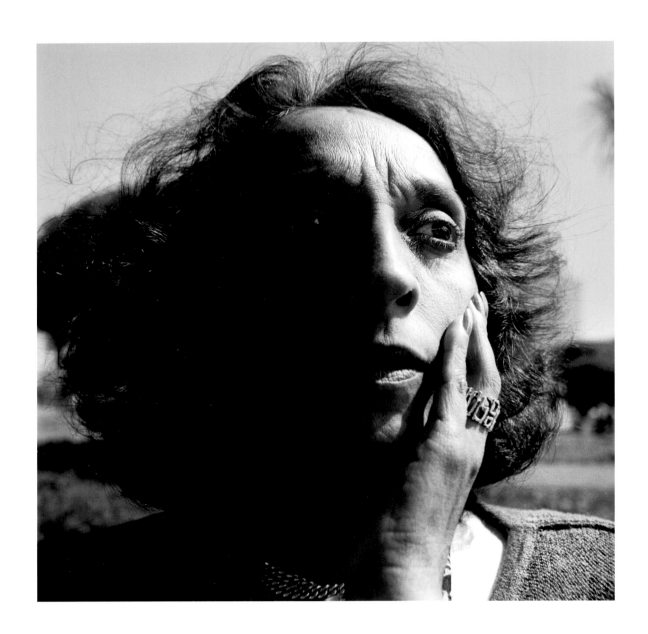

at the thermal baths they tell me
mother died yesterday

i will take you out mother
oh no...you won't

wind nips my fingers
i cross the road of madres olvidadas,
buy limp carnations at the graveyard gate,
sit shivering in a steaming pool

father in his wheelchair
a lonely weenie on his plate

says...goodbye
i'm going
sister rolls him away
all he leaves me is a song

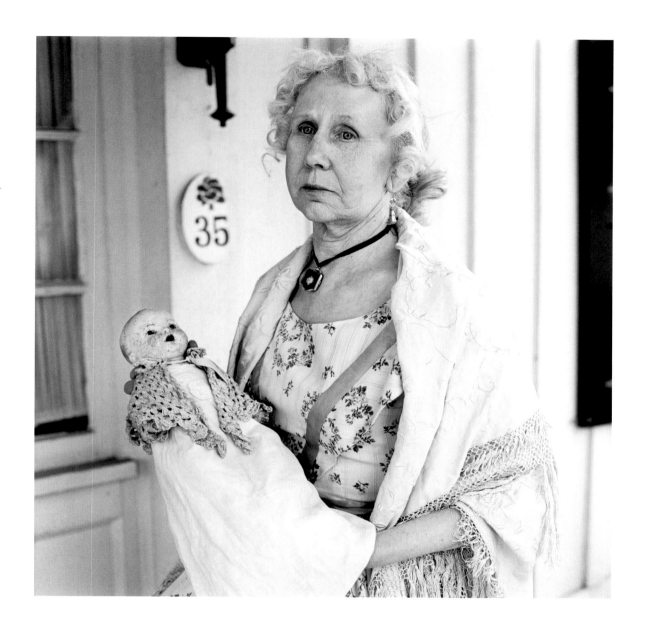

oh you beautiful doll

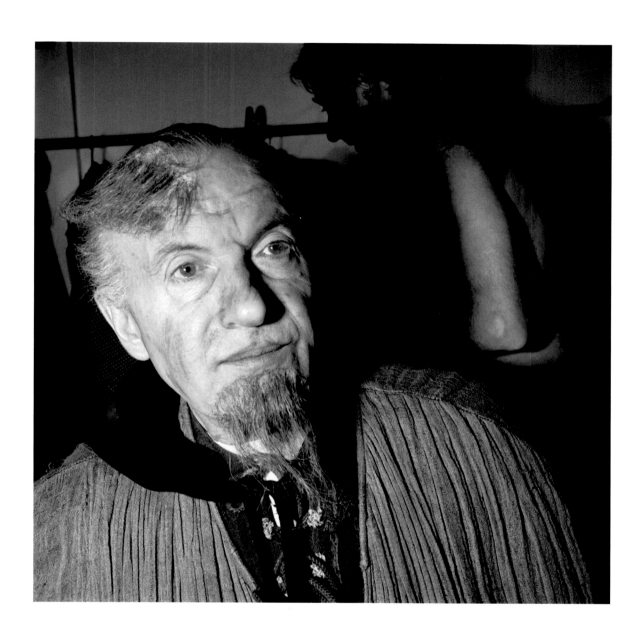

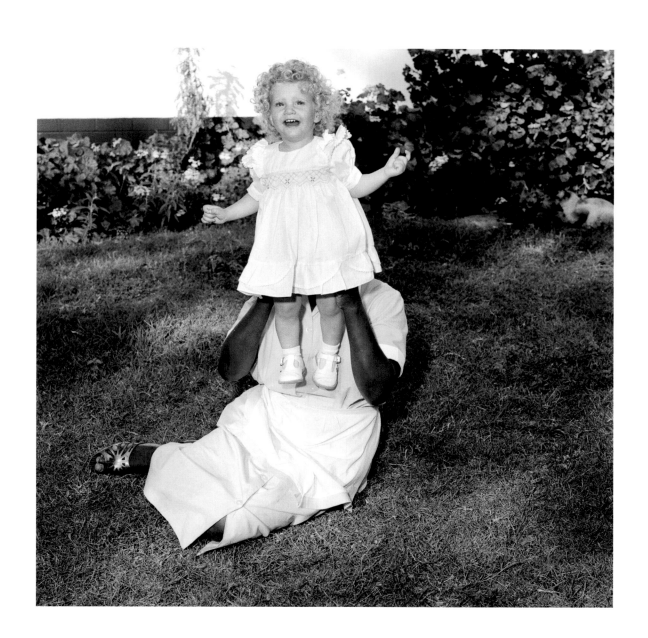

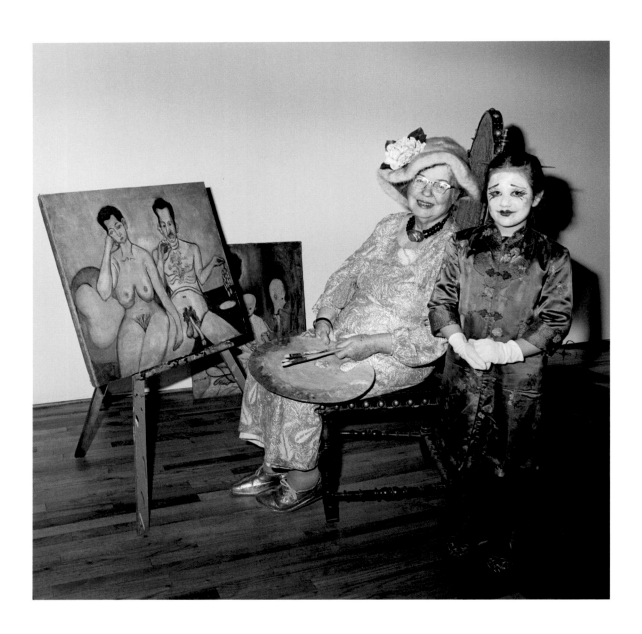

two hands are holding, four legs walking
she remembers making love and wants to again
wants another pair of legs in her bed
ham in the icebox...just for today...

you must have been a beautiful baby
you must have been a wonderful child
when you were only starting to go kindergarten
i bet you drove the little boys wild...
oh, you must have been a beautiful baby
'cause baby look at you now

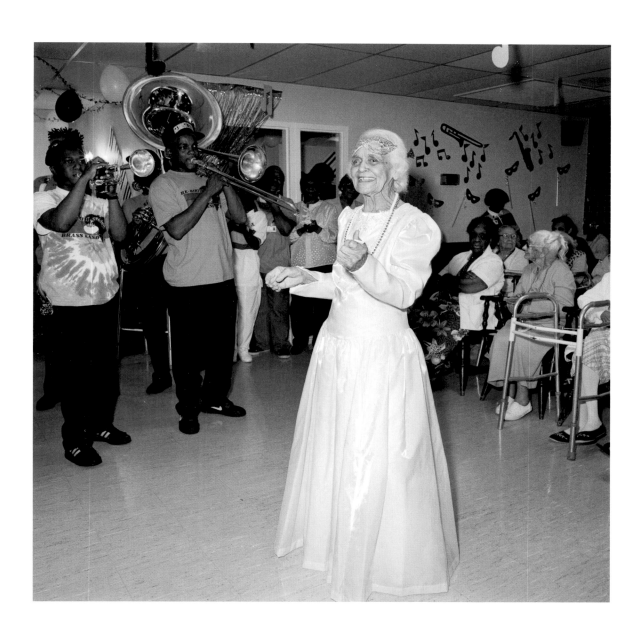

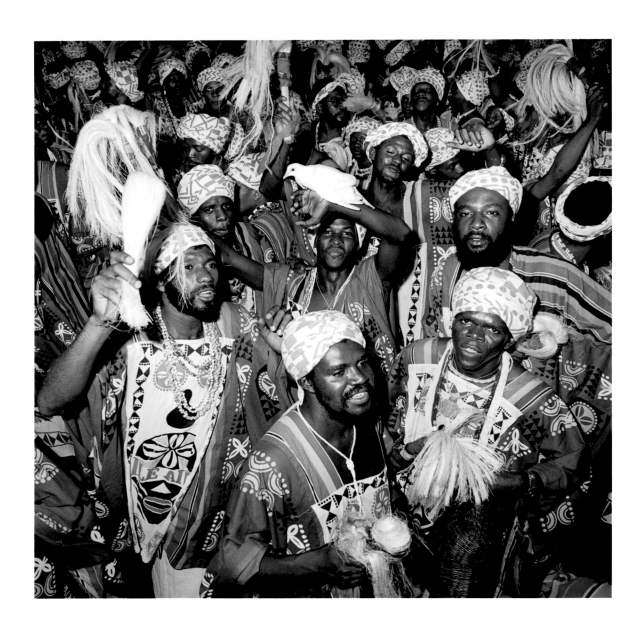

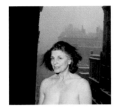

New York, 1986

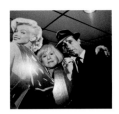

Highland Park
Illinois, 1997

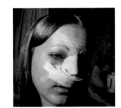

New York, 1977

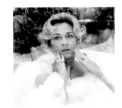

Chattanooga
Tennessee, 1975

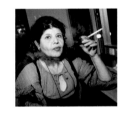

Signal Mountain
Tennessee, 1976

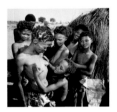

Karoo
South Africa, 1990

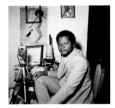

Bamako
Mali, 1988

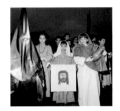

Johannesburg
South Africa, 1988

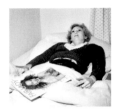

Catalonia
Spain, 2009

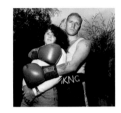

Manchester
England, 1994

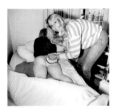

Johannesburg
South Africa, 1988

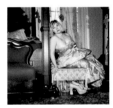

New Orleans
Louisiana, 1992

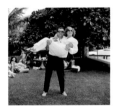

Guatemala City
Guatemala, 1979

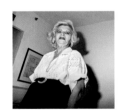

Miami Beach
Florida, 1999

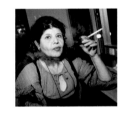

Belgrade
Yugoslavia, 1993

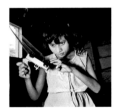

Merida
Mexico, 1985

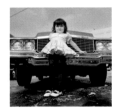

Scottsboro
Alabama, 1974

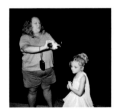

Neshoba
Mississippi, 2001

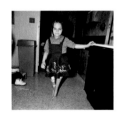

Chattanooga
Tennessee, 1977

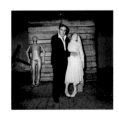

New York, 1982

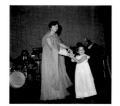

Chattanooga
Tennessee, 1976

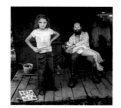

Suck Creek Mountain
Tennessee, 1984

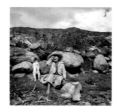

Ancash
Peru, 1981

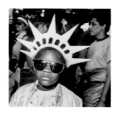

New York, 1987

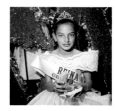

New York, 2000

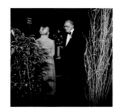

Washington D.C.,
1979

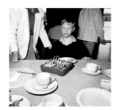

Ancash
Peru, 1995

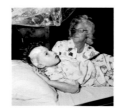

Chattanooga
Tennessee, 1975

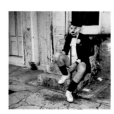

Scottsboro
Alabama, 1974

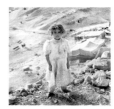

Bedouin Camp
Israel, 1999

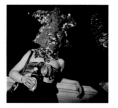

Ft. Lauderdale
Florida, 1982

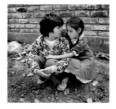

Cape Town
South Africa, 1990

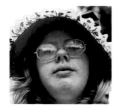

Ancash
Peru, 1980

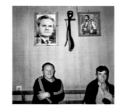

Belgrade
Yugoslavia, 1993

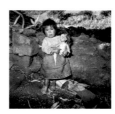

New Orleans
Louisiana, 1992

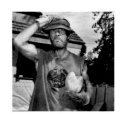

British Columbia
Canada, 2003

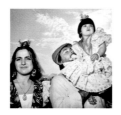

Spain, 1986

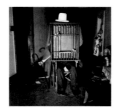

Washington D.C.,
1979

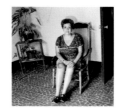

Agua de Dios
Colombia, 1987

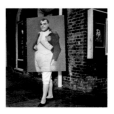

New Orleans
Louisiana, 1992

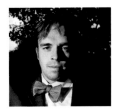

New York, 1999

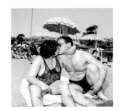

Naples
Italy 2002

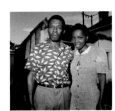

East London
South Africa, 1995

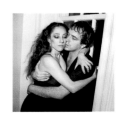

New York, 1980

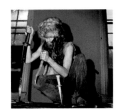

Chattanooga
Tennessee, 1975

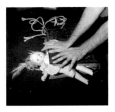

Chattanooga
Tennessee, 1974

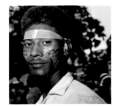

Bahia
Brazil, 1980

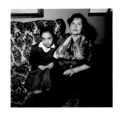

Berlin
Germany, 2006

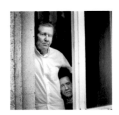

Huaraz
Peru, 1998

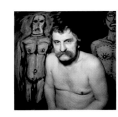

Prague
Czechoslovakia, 1990

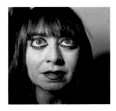

Paris
France, 1975

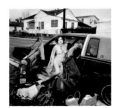

New Orleans
Louisiana, 1994

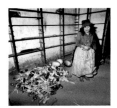

Huari
Peru, 1981

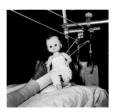

Chattanooga
Tennessee, 1975

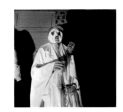

Ringgold
Georgia, 1978

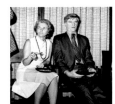

Chattanooga
Tennessee, 1976

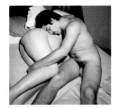

Miami
Florida, 1994

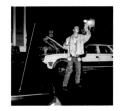

New Orleans
Louisiana, 1992

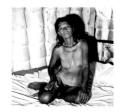

Managua
Nicaragua, 1998

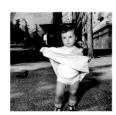

Barcelona
Spain, 1988

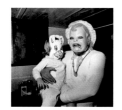

Ringgold
Georgia, 1976

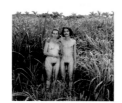

Havana
Cuba, 1992

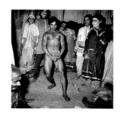

Kulu
India, 1981

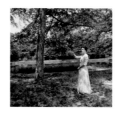

Shiloh
Tennessee, 1978

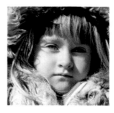

Scottsboro
Alabama, 1975

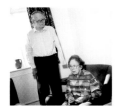

New York, 1986

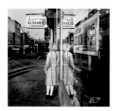

Chattanooga
Tennessee, 1987

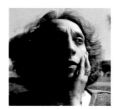

New York, 1990

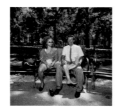

Sarasota
Florida, 1976

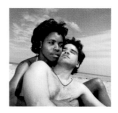

Miami Beach
Florida, 1994

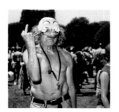

Manchester
England, 1994

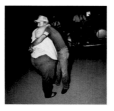

New York, 1979

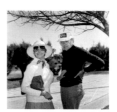

Lima
Peru, 1996

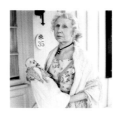

Jonesboro
Tennessee, 1977

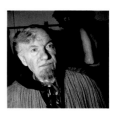

Belgrade
Yugoslavia, 1993

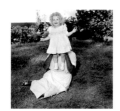

Harare
Zimbabwe, 1991

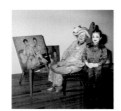

New York, 1978

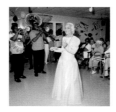

New Orleans,
Louisiana 1992

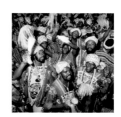

Bahia
Brazil, 1980

All persons living and dead are purely coincidental, and should not be construed.

Kurt Vonnegut

Thanks to all who supported the development of this book:

For the book, the artist wishes to thank Michael Mack, friend and extraordinary publisher, and his colleagues, Izabella Scott and Lewis Chaplin.
For their longtime friendship and great generosity, special thanks to Paul Mahon and Annie Lake Mahon.
For unflagging encouragement and support, thanks to Bruce Silverstein Gallery, Bruce Silverstein and Liam D. Van Loenen.
For writing feedback and affirmation, big thanks to Ruth Danon, poet.
For insight and response to images, thanks to Richard Grosbard, curator and scholar.
For assistance with imaging, printing and evolving mockups, thanks to Shiori Ohira and Mallika Vora. Thanks also to Kate Izor, Jeff Klapperich, and Jonno Rattman.

First edition published by MACK
© 2016 Rosalind Fox Solomon for the images and texts
© 2016 MACK for this edition
Design by Rosalind Fox Solomon & Lewis Chaplin
Printed by optimal media

MACK
mackbooks.co.uk
ISBN 9781910164198